SOUTH WEST WALES

Through the Lens of

HARRY SQUIBBS

VOLUME TWO

Pembrokeshire

PAM FUDGE

AMBERLEY

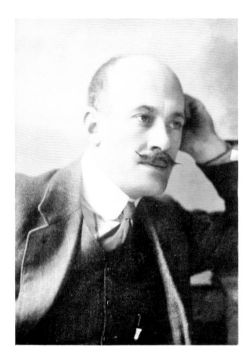

Fig.1: Harry Squibbs (1884–1946)
For my grandfather: artist, photographer,
entrepreneur, avid angler, and his
descendants.

First published 2014

Amberley Publishing
The Hill, Stroud
Gloucestershire, GL5 4EP

www.amberley-books.com

British Library Cataloguing in Publication Data.
A catalogue record for this book is available from the British Library.

ISBN 978 1 4456 3435 7 (print)
ISBN 978 1 4456 3441 8 (ebook)

Typesetting and Origination by Amberley Publishing.
Printed in the UK.

CONTENTS

PART 1
Harry Squibbs:
His Life and Work as a
Photographer and Artist

Introducing Harry

This second volume, together with Volume One (*South West Wales Through the Lens of Harry Squibbs: South Cardiganshire*) provides a record of the life and work of my grandfather, Harold (Harry) Edwin Squibbs. He lived and worked as a photographer, postcard producer and artist in South West Wales during the first half of the 1900s. Postcard collectors will recognise him as Harold Squibbs – the name he used for business purposes. I believe this decision arose from pressure from his father as the 'proper thing to do', despite the fact that he hated the name Harold. As he was always called Harry, this is used in both volumes. I think he would appreciate this.

Included in this book are examples of the work Harry produced in Pembrokeshire. This largely covers those communities along the northern coastal part of Pembrokeshire and along the southern side of the River Teifi, although he did range as far south as the St Davids and Whitesands Bay area. In this volume I've included some of Harry's brother Arthur's postcards alongside his work. These include a few images of Carew, Manorbier, Pembroke and Saundersfoot.

Volume One focuses on Harry's photographic and artistic work along the coast in southern Cardiganshire and inland along the northern side of the River Teifi. The decision about the geographical areas he focused on was by agreement with his older brother, Arthur. Between the two of them, they covered large areas of the two counties.

Both volumes are set out in two parts. Part 1 comprises an introduction and glimpses into Harry's life as a second generation photographer and artist who worked through a time of great change in photographic processing. Included are examples of his various illustrated and photographic work and some of the processes he used at the end of the 1800s and in the first half of the 1900s. The last section of Part 1 also features a table, including examples of the differing styles he used for publishing his postcards throughout the years he worked. These are accompanied by information to aid postcard collectors in dating Harry's work.

Part 2 includes examples of Harry's postcards and photographs accompanied by anecdotal and historical information about the communities featured. As most of this is from my memory of what I learned from my parents and grandparents, I may have included some errors. Do let me know if this is the case.

As both volumes include an introduction some repetition in the first part of each book is inevitable. This will not affect those of you who are interested in only one county and so only want one volume. Those of you who require both volumes will be pleased to see that I have avoided as much repetition as possible. The contents of Part 1 in each book are tackled in a different way and include a few different photographs and processes.

The Idea and Production of a Book About Harry's Work

The idea of producing this book began while sorting out the things I had inherited from my grandfather. I had not long retired, and suddenly I had time to do things that had previously not been possible during my working life. As Harry passed away when I was a baby, I didn't have the opportunity to get to know him, but according to my father he was a very interesting, unusual and amusing man. He was an artist, photographer, entrepreneur and travel agent, who also had a keen interest in writing and in the history of the land around his home in Cardigan. However, his greatest love was for the outdoors and fishing and this became obvious when I began to pay attention to the items I had inherited.

My collection includes his sketches, paintings, etchings, an enormous number of photographs, postcards, negatives, some glass photographic plates and (what really captured my interest) his draft of entertaining short stories about his experiences of 'The Other Side of Fishing'. These short stories provide an insight into his early, very unusual life. I decided to start by editing the short stories in preparation for publishing and I sought out Glen Johnson, our local historian and author living in St Dogmaels, for advice. He recognised the Squibbs name in relation to Harry's photographic work and suggested that the photographic collection I had inherited might provide some valuable historic content for a book capturing South West Wales in the early 1900s. At this point I'd almost completed editing the short stories. However, his notes contained instructions for placing illustrations alongside each story together with a few very unusual photographs he took at night of poaching activities. As the majority of Harry's own illustrations were missing and I had only completed some to replace them, I decided to put this task on hold for a bit and produced my first draft of a book about Harry's photographic and artistic work. My publisher encouraged me to produce the work in two volumes rather than in one book by separating Harry's work between Cardiganshire (Volume One) and Pembrokeshire (Volume Two). The benefit, of course, is that readers now have access to more of Harry's postcards and photographs.

This exercise proved to be an interesting challenge as it meant separating two counties with close ties. I suspect that readers who, like me, were born on the banks of the River Teifi, have families who lived or still live in both Cardiganshire and Pembrokeshire, as some of the villages are separated by the River Teifi and so are in both counties. In this case, you may see the river as a great link between the two counties rather than as a boundary line. This was certainly the case from 1973 to 1994, when the two counties, together with Carmarthenshire, became one county: Dyfed. Readers with interests ranging across both counties may therefore also be interested in Volume One.

The decision about the kind of book I would produce was made and the first step was to contact my cousin, Rob Squibbs. Between us we had a very large collection of materials of historic value. Rob had inherited Harry's negatives and glass plates while I had the postcard proofs he used to catalogue his work and record serial number changes.

To produce the best quality photographs to include in the book it was important to use the glass plates and negatives and Rob loaned them to me to work on. Sadly, our combined collection of plates, negatives and hard copies does not include all of the postcards Harry produced, as when he passed away, a significant number mysteriously disappeared and as yet we have been unable to track them down. Harry's main record keeping system also no longer exists.

When I looked at the collection of 611 glass plates (231) and negatives (380) in two large cardboard boxes, it became obvious that this was going to take far longer than I had anticipated. Each of the glass plates varied in size between 2¾ inches by 6 $^8/_{10}$ inches (7cm by 17.2 cm) and 4 $^6/_{10}$ inches by 6½ inches (11.8 cm by 16.4 cm). Many appeared to be hand cut while others were machine cut. A few were stored in a box labelled 'Gevaert Dry Plates Anti-Halo Manufactured at Gevaert Factories, VIEUX-SIEU, Antwerp in Belgium'.

The solution was to scan each one in two halves and merge them. This worked well, apart from the fact that many of the glass plates were damaged: cracked, chipped and blemished. A few were in pieces requiring assembly like a jigsaw puzzle – quite a challenge when preparing for scanning. My scanner was red hot for months! However, once scanned, the decision was made to limit editing of both the plates and negative to

Figs 2 (*above left*) and 3 (*above right*).

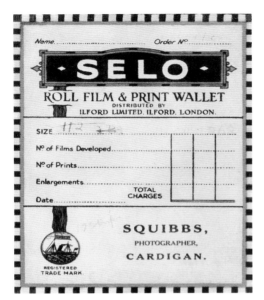

Fig. 4.

removing visible cracks, scratches and blemishes in order that, as far as possible, each photograph retained its original appearance. I hope that if Grandpa were around now he would approve of the results.

Both the glass plates and negatives were stored in paper wallets. Some were kept in the Kodak Wallets shown in Figs 2 and 3 (*previous page*) while most were stored in 'Selo Roll Film & Print Wallets' (*Fig. 4*). These were distributed by Ilford Limited, London, in the early 1900s. On most of the wallets, Harry recorded serial numbers attributed to the particular glass plates or negatives enclosed. Some of these were crossed out and replaced with new numbers. These changes indicated that a new capture of the scene was available, the current one had been given a new serial number as the appearance of photograph had been changed (perhaps from glossy to matt), titles may have been altered or margins removed. The Selo wallet above is an example of this method Harry used to record changes. This one contained eleven negatives of Moylgrove (not twelve strips, as suggested on the cover). On the wallet, Harry has indicated that the postcard numbered 112 would be renumbered as 262.

Figs. 5 and 6 are the actual photographic proofs that matched the negative and the numbering on the Selo Wallet (*Fig. 4*), showing the different appearances of the same photograph. Fig. 5 is Harry's proof that was originally produced in sepia without margins and numbered 112, while in Fig. 6 the serial number was changed to 262 and the postcard printed in black and white on cream card with four margins. The use of cream card gave the photograph a sepia appearance.

Despite Harry's seemingly straightforward storing and catalogue system, the task was not as easy as it may have been as some of the negatives and glass plates had been stored in the wrong sleeve. There's nothing like a challenge in life!

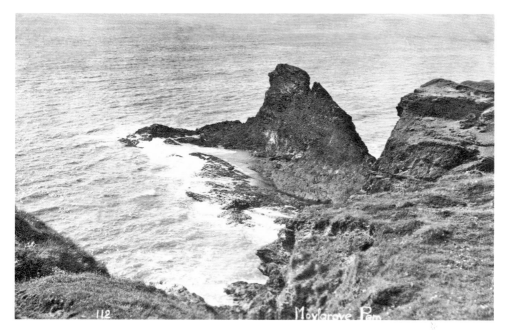

Fig. 5.

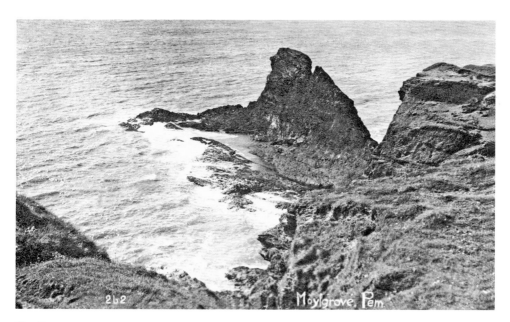

Fig. 6.

Harry's Early Life: The Second in Three Generations of Photographers

Once the decision to write the book was made, I put together all the information I had about Harry, including digging into my memories about my grandfather that were stored from tales my dad and mum had told me about him. I gained some new knowledge from the usual record searches many of us do to build our family trees and learn about our ancestors. The short stories he had written and notes he had left were invaluable. I was left with an insight into a very unusual man who had a great sense of humour and a great love of his family and adventure.

Harry was born into a family of artists and photographers. His parents, Abraham (*Fig. 7*) and Elizabeth Squibbs, were both photographers and artists. Abraham had trained as an artist at the Royal Academy in London. While there, he became interested in the connection between art and photography. This was the era when the newly developing photographic techniques rose into the realm of Fine Art. This was certainly a way of earning more money than would have been the case if working only as an artist. His diary of 1871 showed that he continued his studies in fine art with many visits to the National Portrait Gallery.

Increasingly, he acquired commissions to provide portraits for wealthy families. These opportunities appear to have come from a social, as well tutor–student, relationship with Mr George Scharf, who was Secretary and Keeper of the National Portrait Gallery.

In 1871, Abraham married his fiancée, Elizabeth Watts, in London, and when he returned with her to his home in Bridgewater they set up a photographic business there. This business grew and eventually spanned three generations from 1870s to the 1950s, moving with his sons from England into West Wales. This was during a time when photographic processes changed and were incorporated into his work, that of his sons, Harry and Arthur, and also those of his grandsons, Vivian, Roy, Arthur and Bob.

Abraham's self portrait in oils (*Fig. 7*) illustrates his skill as an artist. Sadly I don't have any of Abraham's photographs of his wife or his sons when they were very young.

However, the close resemblance between the father and his sons can be seen in the photographic portrait of Harry and Arthur in Fig. 8. The brothers took this self portrait when Harry had decided to join forces in business with his brother. Harry is on the left and Arthur on the right.

Abraham began training his sons as photographers and artists at a very early age. They joined him after school or on weekends with cameras or sketch pads. Apart from learning how to use their father's cameras and compose photographs, the boys would have very quickly become proficient in using the gelatin silver process to develop the images they had captured. This process was invented by Richard Leach Maddox. He described the process in an article in the *British Journal of Photography* on 8 September 1871. Maddox's invention was developed by Charles Bennett, who produced the first gelatin dry plates for sale. This new process was found to be preferable to previous methods. No longer would photographers need to carry loads of equipment and a portable dark room around with them if they wanted to capture scenes away from their

home or workplace. Previously, it had been necessary to process their photographs on the spot in order not to lose the image. Now photographers were able to take their photographs using a glass plate coated in an emulsion containing cadmium bromide and silver nitrates in a gelatin base, making it sensitive to light. This ensured that the image was stored safely until they returned to their studio and developed it in a bath of chemicals, when the image would then appear. The first time my dad showed me this happening in his dark room I always remember it as a moment of magic. This method continued well into the 1900s and was used to produce all of those black-and-white photographs that appeared at the time. The results produced by the gelatin silver method gave better detail and were also less likely to fade than was the case with previous methods.

Fig. 9 (*overleaf*) is one of Abraham's postcards produced using this method. My scanned reproduction of this one does not do it justice. It glistens and has great depth of tones. The copyright imprint on the reverse of the postcard (Squibbs & Carey) suggests that, although the photograph may have been taken much earlier, this print was published after Abraham joined forces with a Mr Carey in 1910. The company continued under the name Squibbs & Carey until 1929.

I have included this postcard for a few reasons. Firstly, it was one of the first postcards produced by my family and I believe it is quite rare. Also, Harry used this style for some of the earliest postcards he produced, as can be seen in one of his early postcards taken of St Dogmaels included in Fig. 35 at the end of Part 1 (p. 31). However what tipped the balance was that it was a Squibbs who photographed the 'squibbers' in the photograph. This amused me greatly. The event captured in the photograph is known as 'squibbing'

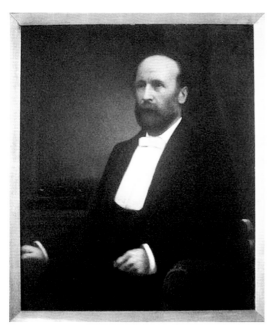 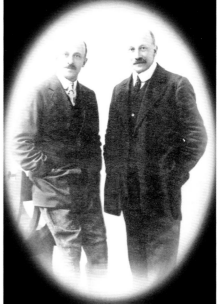

Figs 7 (*above left*) and 8 (*above right*).

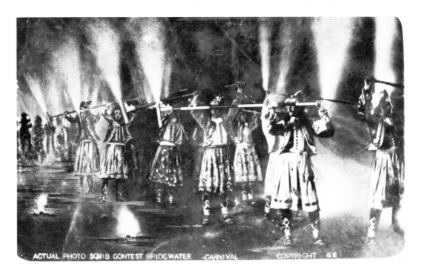

Fig. 9.

and dates back to the Gunpowder Plot. This is an event that Harry, his father and brother would have watched each year with cameras at the ready. The contest still takes place at the end of the Bridgwater Carnival on 5 November each year. Back in the 1600s, the West Country was mainly Protestant and they celebrated the failure of the Gunpowder Plot in this way. Originally, the procession involved participants carrying homemade 'guys' to the bonfire. This later developed into carrying lit squibs. The squibbers were called 'Masqueraders' and, as in the year this photograph was taken, they dressed for the part. The squibber whose squib lasts the longest is the winner. The whole carnival with floats is quite spectacular and well worth seeing. I haven't found any connection between my ancestors and the gunpowder plot but I guess that with the name Squibbs they may have been involved with something to do with gunpowder at some time.

1895 was a year of great sadness for the family as Elizabeth died, leaving Abraham a single parent. The two brothers had always been close, but after their mother's death Arthur, who was ten years older than Harry, took on a caring role, perhaps to free up time for their father. Harry attended the Bridgwater Art and Technical School in Lonsdale House, Blake Street. A prize he received from the school in 1898 stated it was awarded for his ability in producing watercolour paintings. This certainly was the case, as you'll see in his sketch later on in the book (*Fig. 11*). Harry left school when he was about sixteen and seems to have taken off to lead the life of a journeyman, travelling around the UK with his camera searching for photographic work, scenes to sketch, paint and photograph and, of course, places to fish. I can only presume this was his Victorian equivalent of the 'gap years' taken these days by many young people before making a decision about their futures.

Harry's memoirs suggested that the years after he left school were a mixture of unusual experiences, learning to live off the land and sea with very little money and getting to know the ways of poachers. From his notebooks, I discovered that early in his travels he had found his way to Gwbert-on-Sea in Cardiganshire. Harry made friends easily and managed to organise a trip with his new friends across to Cardigan

Island in order to win a bet. He believed that, as eels migrated up the River Teifi, in a storm one might have been blown up on to the island. According to his story, he won the bet although, knowing the height of the cliffs, I wonder if this was a very tall tale. By 1901, seventeen-year-old Harry had found a job in Kings Lynn in Norfolk working as a photographer. I am not sure whether it was he, or his brother Arthur, who first came up with the idea of moving to South West Wales but, while Harry was in Kings Lynn, Arthur and his family moved to New Quay in Cardiganshire. Harry continued his travels with frequent visits to his brother and sister-in-law.

His close proximity with poachers described in his short stories is certainly no tall tale, as you'll see in his photographs taken on one of his nocturnal adventures on an unnamed river in Wales (*Fig. 10*). They were developed by a friend of his in Bristol. He explained his extra-curricular activities in this way:

> At my impressionable age, when I saw new things that smacked of wild adventure and risk, I was naturally not only interested but fascinated and thrilled. So much so that it was some time before I became accustomed to the fact that, unlike the canal I had been used to, I really could not do just what I liked on this water way. Yes, it definitely was 'agin the law' to do this or that without one of those expensive permits.

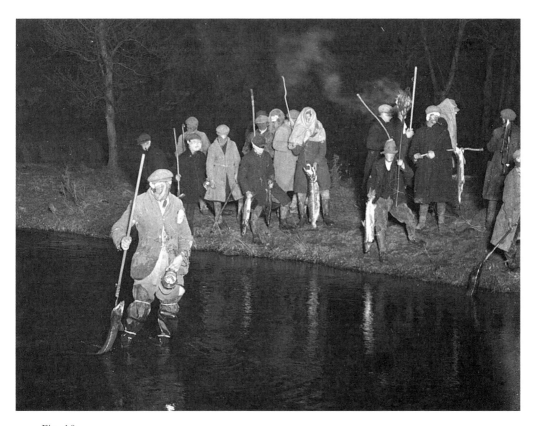

Fig. 10.

From the excitement he experienced on his young travels he began to realise that poaching was endemic, had been going on for generations and, along with fishing fleets at sea, was depleting the fish stock. He never understood why the close-knit groups of poachers trusted him. Perhaps they thought they would convert him to their way of life. They did not succeed and I'm pleased to say that Harry, on occasion, assisted the bailiff. His conversation with a friend later in his life will give you an idea of the danger involved:

> Returning home one night I stopped the car on top of a hill which commanded a grand view of 2 miles of the beautiful river valley. It was a brilliantly clear night and below we could distinguish pin points of lights that flashed here and there. I said to my friend, 'See those pin points of light flashing down there?'
>
> 'Yes! What are they?' he asked.
>
> 'Poachers!' I responded. 'They are at it again.'
>
> 'At what?' my companion questioned.
>
> 'They're after the spawning fish. There are two gangs; usually seven or eight in each gang. I wonder what you would do if you were a lone bailiff patrolling this river?' I asked.
>
> 'Me? Do? I am jolly certain I would go to the pictures,' he determined with no hesitation.
>
> 'What chance has one bailiff against that crowd?'

Harry's Working Life as a Photographer and Artist

In 1907, Harry had fulfilled his aim to return to West Wales and moved to Cardigan, found a home and joined forces with his brother to extend the Squibbs photographic business in the area. He was delighted to be near the River Teifi, which flows out to the sea between Pembrokeshire and Cardiganshire. The area offered all he wished for: beautiful scenery, a coastline that was second to none, a river (which for him was the best 'salmon river' in the world) and people who were friendly and welcoming. He was now also engaged to a young lady called Ada Lucilla Polly Baker. They had met on one of his return visits to Bridgewater. His amusing record of their meeting is not only captured in his notes but is accompanied by a watercolour sketch he was busy with at the time (*Fig. 11*):

> One day I was sketching the river through the branches of a very old oak. Behind me and lower down the river, the still, smooth water spread out forming a mirror of some grand old oak trees with branches reaching from bank to bank. High up in the trees some youths had attached a rope and were having great fun swinging across the water. Presently two young ladies joined them, then the laughter suddenly ceased. A heavy splash was followed by a cry for help. The distance from my easel to the swing I covered in good time. My effort at rescuing the young lady seemed to take ages, but by hanging on to her hair – the only way of avoiding her clutches – I eventually

Fig. 11.

dragged her into shallow water and finally led her up the bank. A few years later I led her to the altar, without struggles, dragging or hair pulling. We still have the sketch.

Harry obviously preferred watercolours as a quick way of capturing scenes while on his travels. His father enjoyed using oil paints.

In March 1908, Harry returned to Somerset, married his fiancée and they returned to settle in West Wales. Ada was a young woman who had worked as a nurse in very challenging situations and thrived on setting up her new home in a different, if not far away, country that she was so impressed with. They both felt that this was a fitting place to start their new life together in their first home in Park Avenue, Cardigan, overlooking Cardigan's sports field. His house is the left half of the semi-detached house next to the bungalow in the top left-hand corner of the photograph (*Fig.12, overleaf*). When Harry took this photograph the scene was of a very rural setting. The sports field it overlooks is now the grounds of the Cardigan Rugby Club and holds a playground, tennis courts and rugby fields. Harry must have taken the photograph either from the top floor of the current Cardigan School of Dancing on Gwbert Road (*Fig. 12*) or a house nearby. Apart from the sports field, all the other fields seen in the photograph are now built over with houses and it looks very different. The inset photograph of my family in the front garden of the house in Park Avenue gives a glimpse of Gwbert Road through the railings, from

which the original photograph must have been taken. Through the railings only one house is really visible, with possibly the chimney of another. The children having a picnic in the garden are my dad, Viv, in the centre with his brothers, Roy and Arthur, to the right and his sister, Joan, and her friend to the left. Their mum is making sure the picnic goes well. I believe Harry took the photograph around 1918. An interesting point for me on a recent visit was to see that the attractive original railings are still on the wall outside the house. Things were certainly made to last then.

Harry's carried out his work from his home until he managed to secure separate premises for his photographic business. His aim was to get one in the centre of town and, by around 1910, he had set up his first photographic studio in No. 51 St Mary Street. He had already expanded his photographic business to include postcard production for local businesses, illustrations and photographs for local newspapers, and sales of artists' materials and books. Although this was just off the High Street and near the centre of town, he wanted a more central location and by 1914 he had moved his studio to No. 38 High Street in Cardigan. Harry's advertisements (*Figs 13, 14 and 15*) show his moves and provide an idea of his increasing diversity in services offered as time went on.

It was around this time that he ventured into his first expansion outside Cardigan. This resulted in a photographic arrangement with someone in Newcastle Emlyn, who I believe agreed to a joint venture. This may have been a joint venture with a

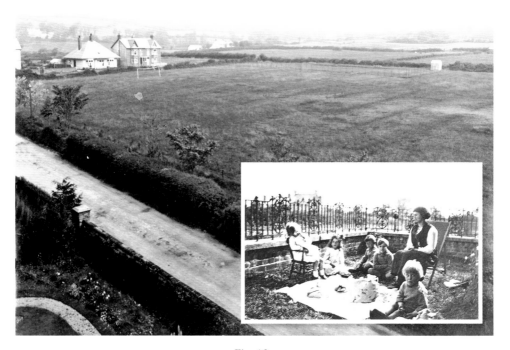

Fig. 12.

Mr E. Davies, who published some of Harry's postcards. The venture lasted through most of the 1920s. I have only one of Harry's postcards and a few photographs taken in Newcastle Emlyn (these are included in Volume One). Later this increase in business also involved setting up a photographic studio in Fishguard that operated through the 1930s and into the 1940s. While Arthur continued his work in Tenby and South Pembrokeshire, Harry concentrated mainly on the towns and villages in Cardiganshire, the northern part of Pembrokeshire, including Newcastle Emlyn.

As was the case for most photographers, Harry's work included the usual ongoing commitments, including weddings, portraits and events of local interest. These photographs often appeared in the *Tivyside Advertiser*, including annual photographs of the Mayor of Cardigan, events such as the Coronation celebrations, carnivals and the annual school photographs. There wasn't much time to spare but whenever he had some Harry continued to paint and sketch. This skill proved to be particularly useful

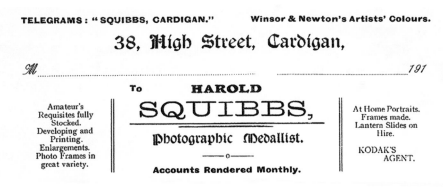

Figs 13 (*top left*), 14 (*top right*) and 15 (*above*).

in the production of portraits. As this was the time before colour photography got underway, people who wanted something really special commissioned a hand-painted photograph. Harry's artistic talent can be seen in his portrait of his wife in Fig. 16. This one is 23 inches (58.3 cm) by 19 inches (48.2 cm) and, according to my dad, similar in size to others he produced. This one is in a gilt frame but customers would have chosen the frames they wanted for their paintings from the stock he held in the shop.

1914 was a terrible year for the family and everyone else in the country as this was the beginning of the First World War. Harry, to Ada's dismay, had volunteered to join the war effort, despite the fact that he was a married man with a family and a business that during the first year of the war meant that he would not be called up. Much to Ada's relief, Harry was not accepted on medical grounds. For Harry, though, this decision was very hard to deal with as he knew he could look after himself in any situation. He considered that he would make a good war photographer and artist. It was a blow for him to learn that medically he was considered not to be eligible for service. So he remained where he was, with far more portraits of a disconcerting nature to take of the young men who volunteered to join the forces. I found a few in my collection, including one of my maternal grandfather, William Neal Counter, as a corporal in the Army Medical Corps. He had survived the 2nd Boer War and was one of the first to join up in Llandudoch (St Dogmaels), leaving my grandma with three little children. Harry took two photographs: one of William for the family (*Fig. 17*) and one of his wife, Rose, and his children, Fred, Dolly (my mum) on the right

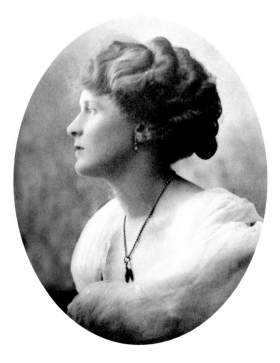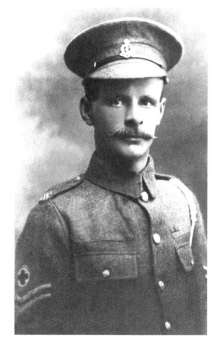

Figs 16 (*above left*) and 17 (*above right*).

and Gladys on the left (*Fig. 18*) for him to take with him. William survived the First World War but, as was the case for many, died at the young age of forty-eight from TB, which he contracted during his war service.

In addition to the uncertainty caused by the beginning of war and Harry's disappointment in not being allowed to join the forces, 1914 became an even more tragic time for Harry and Ada. By then they had four little children: Eileen was five, Vivian nearly three, Roy was one and the youngest, Joan, was just a few months old. There was an outbreak of diphtheria in Cardigan during that year and in December their firstborn, Eileen, succumbed to the disease. Although my dad was very young at the time, he always remembered his older sister as a funny and loving little girl. Harry's hand-painted photograph of his daughter (*Fig. 19*) is a poignant reminder. Harry must have produced it not long before his daughter died. He and Ada hung it in their bedroom and then it took pride of place in my mum and dad's bedroom. It now hangs in ours.

Around the same time, another move had already been planned that must have been difficult to deal with, considering their daughter's illness and loss. However, Harry at last had secured the central location in town that he had been looking for, although at that time it could have been little consolation after losing their first child.

Bank House was a larger property on the High Street in Cardigan, providing more room to expand his business and diversify. It is the tallest building in the centre of the sketch in Fig. 20 and was the place I remember looking forward to visiting as a child. When Dad came home from sea we would go into the shop to visit Grandma. It always seemed like an Aladdin's cave to me. Entry was up a step and through the two large

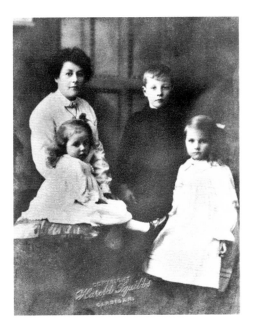
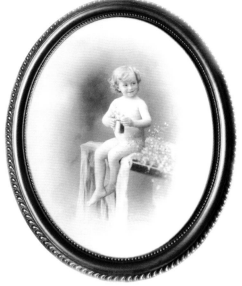

Figs 18 (*above left*) and 19 (*above right*).

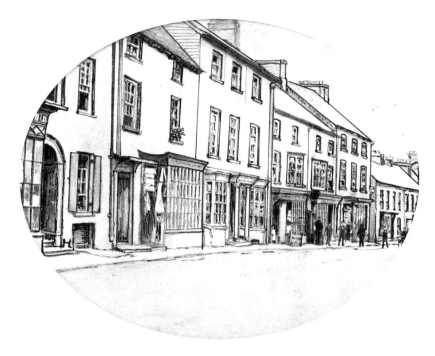

Fig. 20.

pillars at the front of the building. The room on the left was the place to go to buy a fishing license, rods, bait and all the accessories you would need for fishing and catching the biggest salmon, bass or trout. There were also wicker or canvas creels to put your catch in to carry home. This part of the shop was my favourite as it also contained all of the paints, pastels, canvases, brushes, pencils, charcoals and sketch pads you could possibly need to produce a work of art. It amazed me how much was packed into this area. Also on sale were a selection of reproductions of famous paintings along with Harry's own watercolours and etchings, which could be bought and framed if required. And, of course, there were always cameras there for sale as well. The one in Fig. 21 was an example of what was on sale for amateur photographers and came from the shop. The other half of the shop was the place to go to buy sweets, tobacco, pipes and cigarettes or book a passage to New York. Since completing Volume One, I have found that Harry also sold His Master's Voice gramophones and records, along with musical instruments.

At the back of the building was the photographic studio, with the background curtains painted by Grandpa, where people posed to have their photographs taken. Upstairs were the developing room, the living areas, kitchen and Grandma's classy café (*Fig. 22*).

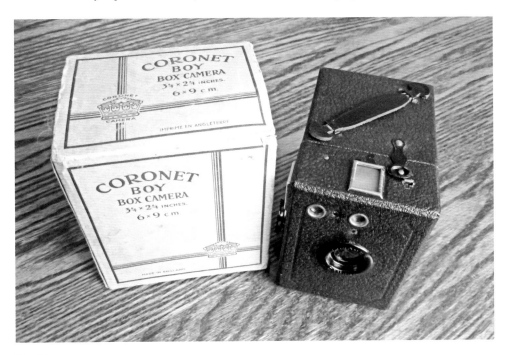

Fig. 21.

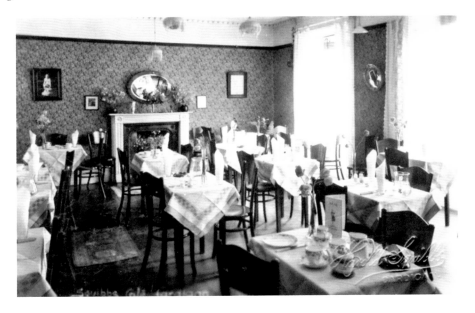

Fig. 22.

The Need to Diversify: More Processes and Products

Harry, like many photographers at that time, diversified to include a large variety of products and methods of making money. To solely rely on photography would have given the family a meagre income. Harry therefore used his skill as an artist to increase the options he could offer his customers. In addition to hand-painted portraits similar to the one in Fig. 19 (*p. 19*), Harry also produced miniature portraits. An example based on the full-length oval portrait in Fig. 19 can be seen in the miniature below (*Fig. 23*). The process involved using the original glass plate, selecting only the head and shoulders to develop it and then hand painting the photograph using specialist oil paints. This allowed Harry to produce a very small copy of part of the original oval

Figs 23 (*left*), 24 (*below left*) and 25 (*below right*).

photograph in Fig. 19, which is 1 ft 7 in. (48.3 cm) tall by 1 ft 3 in. (38.1 cm) wide. In comparison, the circular miniature (*Fig. 23*) is only 2¼ in. (5.6 cm) in diameter without the frame and 3¾ in. (9.5 cm) including the frame. Harry produced this one for my dad, who was pining for his sister who had passed away.

In comparison to the miniature in Fig. 23, the two tiny portraits in Figs 24 and 25 are even smaller and were produced in a different way. These were hand drawn and painted using watercolours on velum. The tiny paintings are exquisite in detail and both are just 1¼ in. (3.2 cm) tall by 1 in. (2.5 cm) wide to fit perfectly into the locket of the lady who commissioned them around 1911. She was Mrs Rachel Trail, who had returned home to live in St Dogmaels after the death of her husband. The paintings are of her son, Anthony, and daughter, Mary Dorothy (Dot). Dot, who was our village post lady, inherited the locket when her mother died. As neither Anthony nor Dot had any descendants, Dot decided that the locket be returned to my family. It was her contention that as Harry had produced the portraits then the locket should be returned to his family. I feel privileged to have inherited such a beautiful object via my parents.

These two unusual processes were included in Harry's repertoire. They offered bespoke portraits to customers who wanted something a bit more special than the usual black-and-white or sepia photographs favoured by most people in those days.

Yet another aspect of Harry's photographic work came to light as I searched through my collection of family records and books. He produced photographs and illustrations for authors' books and guidebooks, including: *Key of All Wales* by Col. Sir John Lynn Thomas, who wrote the inscription in Fig. 26 inside the cover;

Fig. 26.

Cardiganshire Antiquarian Society. Transactions and Archaeological Record Vol. 2 No. 1, Ed. Professor E. Tyrrell Green & Sub-editor D. Ernest Davies MA; *The Church Plate of Cardiganshire* by Revd John Thomas; *Cardigan ('Teify Side') The Official Guide*, issued under the Auspices of the Cardigan Town Council. The photographs in these guides were commissioned by Raphael Tuck that can be seen inset in the bottom right-hand corner of Fig. 26.

Harry's Processes Are Passed Down Through the Generations

The practice of passing on a trade or profession through the generations was common in my great grandfather's and grandpa's lives. This was certainly the case in the Squibbs family. In each generation, skills were passed on to the next generation at a very early age. Harry, like his father, continued this practice and by the time his four sons were teenagers they were familiar with the principles and practice of photography.

Harry's Etchings & Postcard Production

The greatest record of Harry's work lies in the postcards he produced. However, according to my dad, Harry used his etching of Cilgerran in Fig. 27 to produce one of his first

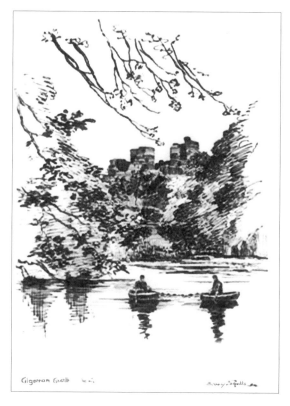

Fig. 27.

postcards. This may have been a one-off postcard, perhaps a trial run, as it is the only one of its kind in my collection and I haven't seen another like it that is postcard sized.

Etching was a process Harry enjoyed as a way of reproducing more than one copy of his art work at a time. His other etchings were usually around 12 in. by 14 in. (30 cm by 36 cm), as is the one in Fig. 31 of Manorbier Castle, Pembs and Fig. 32 of Carew Castle in Part 2 of this book. He produced the former one in 1934, numbered it as the second of this limited set of prints and signed it.

Handling Harry's etchings reminded me of learning this straightforward process, that can result in a set of limited edition prints. The two photographs below were taken by Harry of his son, Viv, demonstrating this process. Although only two of a set of six remain, I decided to include them as they show the dark room in Bank House where Harry and his sons developed their photographs.

Etching involves cleaning and coating a metal plate with an 'etching ground' (i.e. a wax film). The first part of the process can be seen in Fig. 28. Then a metal-tipped etching pen (*Fig. 29*) is used to draw the image required by cutting through the coating to the metal sheet. The etching pen in the photograph has quite a broad tip and is one of mine – previously Dad's and possibly one of Harry's. It's rather worn but still working.

The metal plate is then dipped in acid that cuts into the exposed drawing on the sheet. The wax protects the areas not drawn on. When the wax ground is removed, the etched drawing is left. This has ink squeezed into the lines of the drawing that

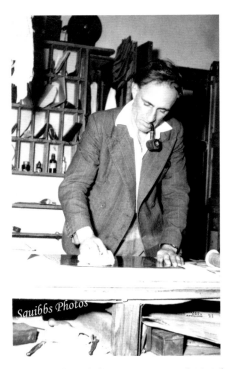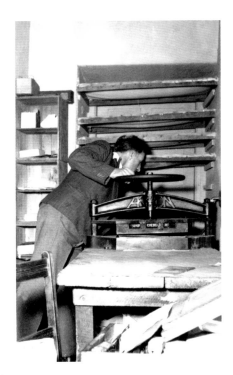

Figs 28 (*above left*), 29 (*centre*) and 30 (*above right*).

are cut into the metal sheet and the surplus is carefully wiped off so that the ink only remains in the engraved lines of the drawing. Then a damp paper is used to cover the sheet and it is placed in a press, as my dad is doing in Fig. 30 (*overleaf*).

When the print is removed from the metal plate, all that the artist has to do is sign and number it, as Harry did in his etchings of Cilgerran (*Fig. 27*). Harry sold these etchings in his shop and I wonder how many of those that he sold are still out there hanging on someone's wall. He also sold reproductions and prints of the work of artists of the nineteenth and twentieth century. I still have some of these reproductions of landscapes and river scenes that Harry bought from Windsor and Newton Ltd. They were produced by a Swiss company, Vouga & Co. Editeurs, Geneva. The smaller prints by the artist F. Leteurtre and H. Barbier were approximately 13 in. by 7 in. while the larger ones by L. Burleigh Brughl were almost poster size (20.6 in. by 13.8 in.).

The Annual Calendar Production and Hand Painting Photographs

This was an annual task I remember being involved with when I was quite young and dates back to the time after Grandpa died. This was a time when his sons shared the responsibility of helping their mum keep the business going. My dad returned

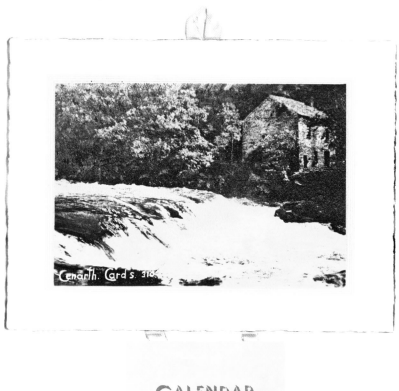

Fig. 31.

home from the Merchant Navy in 1949 and had responsibility for the photographic end of the business. In order to ensure that the calendars were available for sale from November onwards, everyone in the family who was able to do this sort of work was involved. Once coloured, the photographs were attached to mounts, as can be seen in Fig. 33, and little calendars were attached to the bottom. The responsibility for Harry's routine was continued by at least one of his sons each year for quite a few years after he passed away.

Dad would arrive home from Bank House in Cardigan on weekends with a box full of the mounts, postcards, calendars and glue. When I was very little, he brought reject photographs for me to practice with while he and Mum got on with the task. It was very exciting when I was about ten years old and Dad decided that my sketching and painting skills were good enough to tackle a postcard that would be used. Mum covered the dining table with an oil cloth cover and got out the photograph tinting box with tubes of oil paints, the bottles of distilled turpentine and sizing fluid, brushes, match sticks and cotton wool. Although watercolour, pastels or crayons could be used,

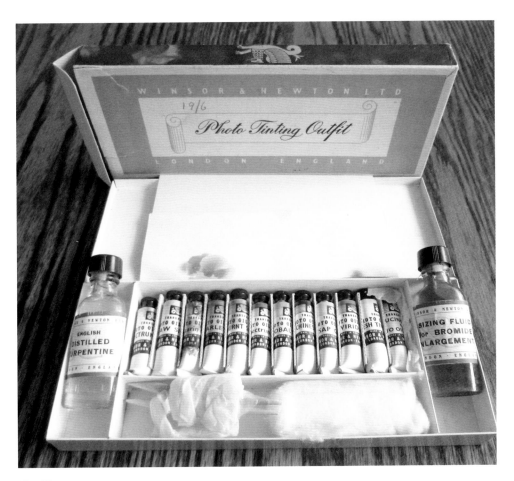

Fig. 32.

Grandpa, like his father, preferred to use oils that always appeared to me to be almost transparent, unlike the usual oil paints. The kit in Fig. 32 (*previous page*) was my prize gift when I passed the 11-plus exam. As you can see, I avoided using it and used Dad's, as I wanted it to last a long time.

First, the photographs were prepared for painting. This involved rubbing each photograph with a few drops of the sizing fluid on cotton wool folded inside a piece of fine cotton. I don't remember how long it took to dry but it always seemed to take ages when I was keen to get started on mine. When the prints were dry, Mum and Dad would each take two or three photographs with similar scenes to work on. As they were mostly countryside scenes, many of the colours required were similar in each photograph. So mixing colours for trees with autumn colours, the river, sea or buildings could sometimes be applied across a couple of photographs at the same time. This was tricky, as there was always the threat of smudging the work done and getting paint all over my sleeves, so for a long time I was restricted to one at a time. We each had an old plate for mixing our colours. The turpentine was used to thin the paints, which were almost transparent when mixed. The large areas like the sky or sea were worked on first using either very little wads of cotton wool wrapped around matchsticks and then covered with tiny little pieces of silk or fine cotton. Mum would make these tiny brush substitutes in the winter. I preferred using the fine artist's brushes, which were essential when dealing with the areas needing minute areas of colour.

The problem that occurred when this took place at home in St Dogmaels rather than in Bank House was finding space to lay the photographs out to dry. This took

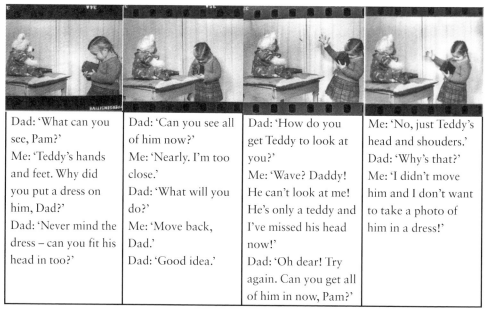

Dad: 'What can you see, Pam?'	Dad: 'Can you see all of him now?'	Dad: 'How do you get Teddy to look at	Me: 'No, just Teddy's head and shouders.'
Me: 'Teddy's hands and feet. Why did you put a dress on him, Dad?'	Me: 'Nearly. I'm too close.'	you?' Me: 'Wave? Daddy! He can't look at me!	Dad: 'Why's that?' Me: 'I didn't move him and I don't want
Dad: 'Never mind the dress – can you fit his head in too?'	Dad: 'What will you do?' Me: 'Move back, Dad.' Dad: 'Good idea.'	He's only a teddy and I've missed his head now!' Dad: 'Oh dear! Try again. Can you get all of him in now, Pam?'	to take a photo of him in a dress!'

Fig. 33.

about twenty hours. As there was more space in my grandma's bedroom, this is where they were laid out on sheets of paper surrounded by a clothes horse to avoid any of us forgetting they were there and stepping on them.

When I came across the little strip of negatives in Fig. 33, I was reminded that two of Harry's sons (my dad and my Uncle Roy) had attempted to continue the photographic tradition down into the fourth generation. My cousin, Mary, and I both had some lessons from our dads. Memory of my first lesson in 'portraiture' came back to me with great pleasure and amusement. I think I was around six or seven years old. It was an exciting day as Dad and Mum took me over to Bank House and into the studio with teddy in tow. Mum took the photographs of me while I took photographs of teddy and Dad gave us both instructions. I have no idea what all of the results of my attempts were like as I only that these four negatives of Mum's to remind me of the experience. Surprisingly, I do remember a little of the conversation with lots of laughter but not feeling very happy about my teddy having to wear a dress. I do remember that later photographs I took with my mum's box camera resulted in whole bodies being included and positioned quite well and that Dad complimented me on them. Dad's lesson must have had some effect on what I saw through the lens.

Neither Mary nor I became professional photographers and so it hasn't continued into the fourth generation (unless producing these two volumes about Harry's work counts). We both, however, did continue Harry's love of art by starting our further education in art colleges and I still always carry a camera with me wherever I go. As you'll see, producing Volume One and this book does demonstrate my fascination with photographs and enjoyment of processing them.

As Harry got older he relied greatly on his sons for support with his business. This became difficult during the Second World War as his three oldest sons had joined the forces. My dad and his brother, Roy, were officers in the Merchant Navy and had transferred into the Royal Navy Reserves. Arthur, who started off in the Army, was quickly transferred to the RAF and became a squadron leader attached to Bomber Command. He was Squadron Leader 121396 in the 619 Squadron. Arthur's last flight in Lancaster LM 209 code PG-H was from Dunholme Lodge in Lincolnshire on 11 September 1944. The Lancasters on this raid headed for the Darmstadt area. They were under a great deal of flak and his plane along with one other was lost. The families of the crew were informed that they were missing. It was a long time before the plane was found and any hope my family had of Arthur surviving was then removed. They were informed that the crew survived the crash but had been murdered by the locals, although no further details were given. Apparently, Hitler's orders stated that Allied airmen were terrorists because they bombed German cities. It's hard not to think about the families of the other members of the crew who had flown together with Arthur on many flights like this one and so it's only fitting that they be mentioned.

Arthur's crew were Sgt James Davison from Northern Ireland; Warrant Officer Class 1 Lloyd George Evans of the Royal Canadian Air Force; Sgt Albert Furnival, the Flight Engineer, from West Bromwich; Sgt David Greenley, the Air Gunner, from Anlaby, Yorkshire; Flying Officer James Francis Parry Air Bomer; and Flight Sgt John Singer, the Navigator, from Aberdeen.

The unusual photograph below in Fig. 34 was taken by Harry of his son Arthur in his Lancaster. You'll see Harry's blind stamp on the bottom left-hand side of the photograph. Harry was a very resourceful dad. Harry passed away two years later, aged sixty-six, leaving Ada, who never really recovered from the loss of her son and her husband.

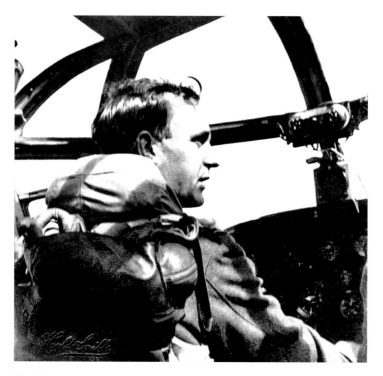

Fig. 34.

Dating Harry's Postcards

Fig. 35 will give you a glimpse into the changes in Harry's postcard production in consideration of colour, finish (matte or gloss), copyright imprints, titles and numbering. I have used Mr Peter Davis' system of dating Harry's postcards, along with access to postcard collections held by Mr Cyril Burton and Mr Glen Johnson for comparison.

Fig. 35: Harry's Changing Photographic Styles		
Appearance	Notes	Production & Mailing Dates
SQUIBBS, Photo, CARDIGAN.	One of a set of fifteen dark matt sepia postcards with one margin at the bottom, including Regatta Day, Cardigan Church, The Netpool near Cardigan, and this one of the St Dogmaels Seine Net fishermen. In the margin is written 'Reg. by the Cliff Hotel', identifying who ordered the commission.	Produced *c.* 1910 and mailed 1910s and 1920s.
Squibbs, Cardigan	Two imprints were used for this one: a blind stamp, 'Harold Squibbs' (*front*) and 'Squibbs. Cardigan' (*reverse*). Each of the imprints was used on real photographs with handwritten titles in capital letters and serial numbers. Also produced in black-and-white on glossy white paper. This one was used in 1937 on Coronation Day.	This style was first used *c.* 1910s. It was mailed 1911–13 and later from 1937 onwards.

Fig. 35: Harry's Changing Photographic Styles		
Appearance	Notes	Production & Mailing Dates
Squibbs, Copyright, Cardigan.	Black-and-white real photograph printed on very pale cream card gives a sepia appearance. Title and serial numbers in capital letter. The first of the imprints on the reverse is an early one. The second imprint was used later and with different styles. This is one of Harry's postcard proof he used to record changes. His handwritten '71' in the top margin indicates a change from 211 in the title.	Produced *c.* 1912/13 and mailed through the 1920s.
Harold Squibbs, Cardigan	Glossy sepia real photograph. The caption in this one is to the left with serial number to the right in capitals and letter-press print with the simple imprint on the reverse. In some the caption is to the right with serial numbers to the left.	Produced *c.* 1910s and mailed through the 1920s and 1930s.
Harold Squibbs, Cardigan	One of Harry's rare hand-painted postcards with handwritten title on bottom left/imprint on reverse.	Produced *c.* 1912–15.

Fig. 35: Harry's Changing Photographic Styles		
Appearance	Notes	Production & Mailing Dates
Squibbs, Cardigan	Real photographic postcard produced in sepia as well as in black-and-white. The upper case letter-press title may indicate that he was commissioned to produce this series.	Produced *c.* 1912–20 and mailed *c.* 1912–32.
	Black-and-white real photograph with handwritten title and serial number on bottom right.	*c.* 1934–1940s.
	Black-and-white real photograph with handwritten title and serial number close to centre on the bottom.	*c.* 1935–1940s.
	First published as real photograph in sepia with curved corners against four margins and later in black-and-white real photograph with handwritten title and serial number on the bottom right.	Produced *c.* 1911–13. Posted *c.* 1934–40 with this imprint on the reverse.

Fig. 35: Harry's Changing Photographic Styles		
Appearance	Notes	Production & Mailing Dates
FREE INFORMATION OF CARDIGAN & DISTRICT, Apply SQUIBBS, PHOTOGRAPHER, CARDIGAN.	First published as real photograph in sepia with curved corners against four margins, and later in black-and-white real photograph with handwritten title and serial number on the bottom right.	Produced *c.* 1911–13. Posted *c.* 1934–40.
Copyright Photograph by SQUIBBS, CARDIGAN and FISHGUARD.	Sepia real photograph with handwritten title prefaced with serial number on the bottom left. The Imprint reads 'FREE INFORMATION OF CARDIGAN DISTRICT Apply SQUIBBS PHOTOGRAPHER CARDIGAN'.	Produced *c.* 1930–35 and mailed into the 1940s.

Just One More of Harry's Clever Techniques

Earlier in the book I mentioned the gelatin silver method of photography used by Harry. Another method was called gelatin silver glass inter-positive. This worked by using one of his negatives to print an image onto a glass plate rather than paper. The result was a positive image as opposed to a negative. This allowed Harry to add his own details to his photographs. He was not only able to write his titles and serial numbers on the glass plate but also draw on it. If the sky looked rather dull he drew in his own clouds, while in many you may notice a swan or seagull. These are quite likely to have been his additions. Once he had added his final details the glass plate was then used to produce the updated postcard.

Part 2 follows and I hope you enjoy visiting Pembrokeshire in the past through Harry's photographs.

PART 2
Communities in Pembrokeshire and South of the River Teifi in the Early 1900s

Abercych & Boncath

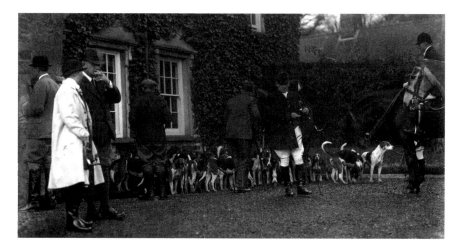

Abercych is a very small village on the banks of the River Cych, where it joins the River Teifi. Part of it is in Carmarthenshire and part in Pembrokeshire. Harry's postcards of Abercych are missing. However, these are some that he took of a hunt meeting somewhere near Abercych. In the last photograph in this set of four, the hunt had arrived in Boncath, a village close to Abercych. I believe that these photographs are of the Tivyside Hunt which, as its name suggests, operated on both the Cardiganshire and Pembrokeshire sides of the River Teifi. According to Harry's notes, the hounds in the photographs are recorded as Mr Brooks' hounds.

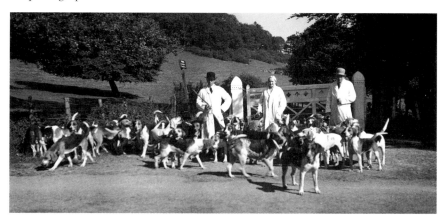

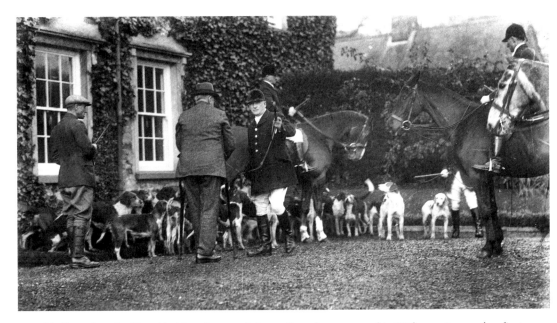

I believe that the Tivyside Hunt is one of the earliest that operated in Wales, as it was the first registered *c.* 1736, with its headquarters in Cardigan at the Black Lion Hotel. It certainly continued to run with just a few breaks between 1926 and 1937, followed by another between 1950 and 1954. Back in the eighteenth century, the hunt was given permission by a prince at the time to have an emblem containing the three feathers of the Prince of Wales.

The photographs could have been taken between 1910 and 1926, or sometime after 1937, when the hunt was restarted as the Tivyside Farmers' Hunt. There has been a great deal of controversy about fox hunting and you may like to check out the Clifford Pellow Story website for interesting information about both sides of the argument and what was actually involved in this sport.

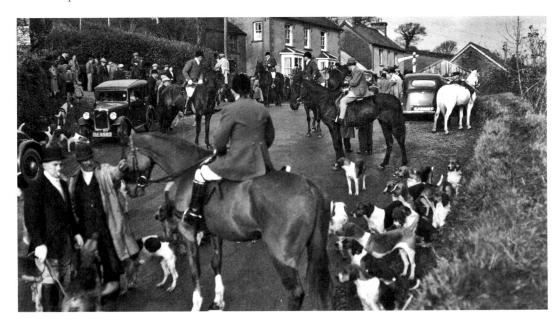

Carew

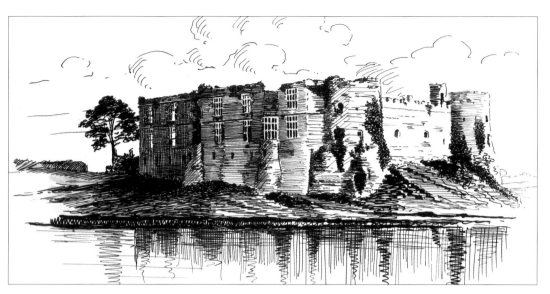

As this was part of Harry's brother Arthur's area, I only have three images for Carew: Harry's etching of Carew Castle and Arthur's two postcards below of the castle and the Celtic cross. The site of the castle dates back to an Iron Age fort. Gerald de Windsor received this site when he married Nest, who brought it as part of her dowry as a princess of Deheubarth *c.* 1095. He decided to build his own Norman keep on the site surrounded by wooden walls. There's more about him and his wife Nest in the next page on Cilgerran. The castle has remained in the Carew family apart from a spell from 1592 to 1607. It's now administered by the Pembrokeshire Coastal National Park.

Near the entrance of the castle is a Celtic cross. Its age hasn't been determined, although one suggestion is that it might date as far back as the ninth century. The other thought is that the Latin inscription carved on it might relate to the death of Maredudd, son of Edwin, in 1035. Maredudd and his brother Hywel shared ruling the kingdom of Deheubarth at the time. Both ideas could be true as the cross may have been there long before and then used as a memorial.

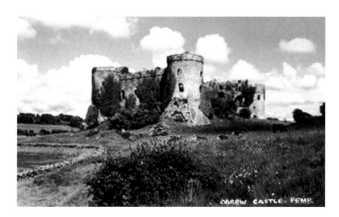

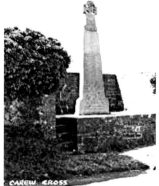

Cilgerran

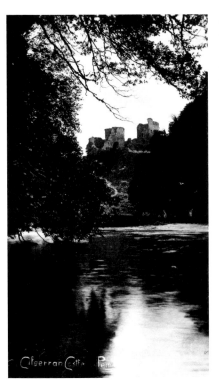

Cilgerran is a village I particularly liked as a child. This was based on my mum's storytelling. She made up stories based on a girl called Katrina and her adventures when she walked through a magical portal to visit her friends, the tylwyth teg (the fairies). I loved these stories, but the one I loved best was a true story she told me had happened in Cilgerran Castle. The castle was built around 1100 by King Henry I, who made Gerald of Windsor Lord of Cilgerran, and he was married to Princess Nest, the daughter of the ruler of the kingdom of Deheubarth. In 1109, Nest, who wanted to get rid of her husband, persuaded her lover, Owain ap Cadwgan, to attack the castle. However, her husband, Gerald, escaped through the garderobe (toilet), landing in the cesspit. Gerald had his revenge later by ambushing Owain and killing him. Over the following centuries, the castle was battled for and changed hands between the English and Welsh until after being damaged in Owain Glyndwr's time in 1405, when the Crown took possession of it.

I was always impressed that they had toilets in castles all that time ago, but would have preferred to go through the gate to get out of the castle. In those days, it would not have been as easy as going through the one in Harry's photograph below. Cilgerran Castle is now a National Trust property.

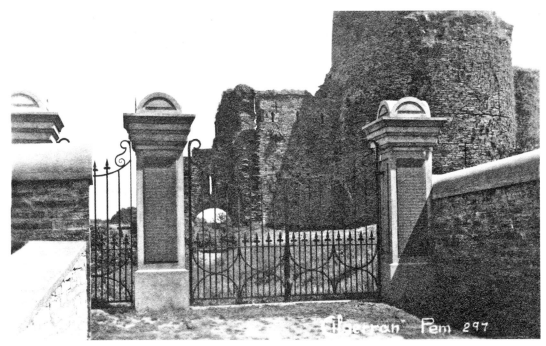

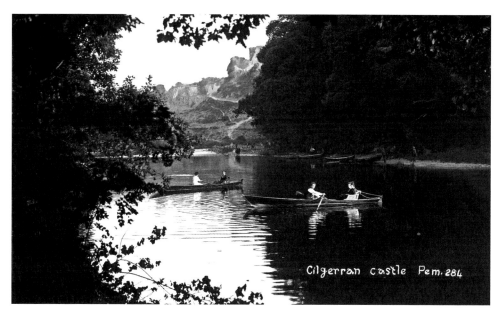

Scenically, of course, Cilgerran provides spectacular views of the River Teifi as it flows through the dramatic gorge below the castle. When this photograph was taken, the river offered pleasant boating opportunities. In the background on the other side of the river you can see the path from the castle that the rowers have scrambled down to hire their boat, while in the shade on the banks of the Teifi are the boat owners waiting to rent their boats. The gentlemen upriver in the photograph below have a different craft: their gwrwgl (coracle) was used to fish for salmon or sewin (sea trout) to sell or feed their families. There is more information about coracles and coracle fishing in Volume One.

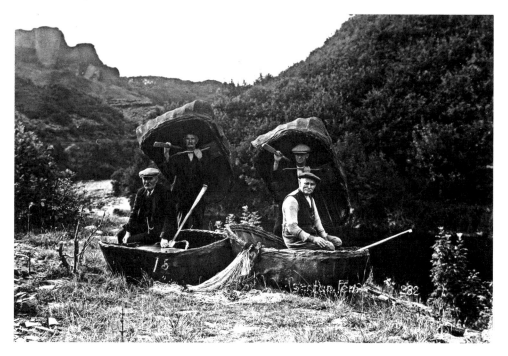

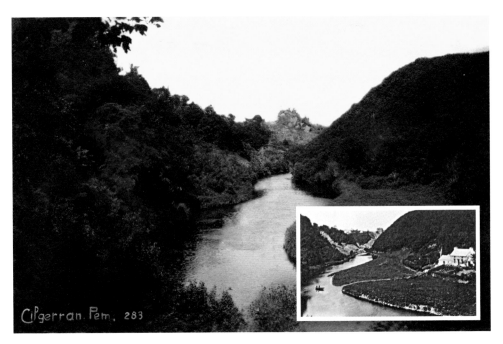

This hand-painted photograph shows Cilgerran Castle in the distance. It was one produced for one of Harry's calendars but not used, possibly as it was thought not to be good enough. It doesn't include the cottage (Plas y Meidw) shown in the earlier black-and-white inset. This one also includes a path to the river used by the quarry workers to get to work at the slate quarry by boat. The high quality slates quarried here were exported down to the river via a short rail track, onto ships and out to the sea. They returned with lime used for agriculture.

Cilgerran has had a school since at least 1833 when S. Lewis noted that there was a school there with forty children attending. The local gentry contributed financial support to run the school. The plaque in the photograph dates it back to 1845. Perhaps the school was extended then to incorporate the left hand part of the building. Now Cilgerran has a newer, larger primary school: Ysgol G Rh Cilgerran/Cilgerran Church in Wales V C School.

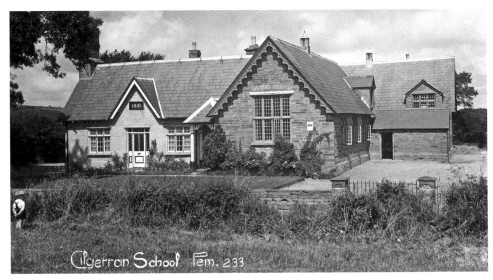

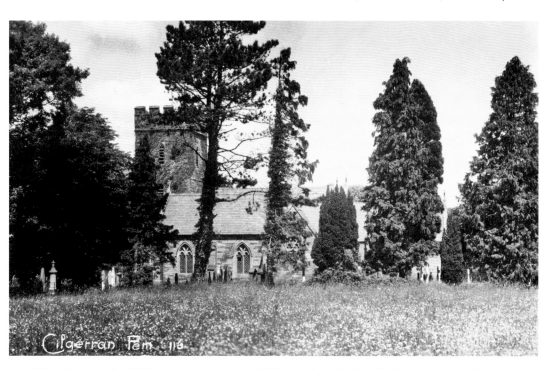

This photograph of Cilgerran church was published both in black and white and sepia, although I don't believe many sepia copies were made. The church tower is the oldest part of the building dating back to the thirteenth century, while the rest of the building was built in the 1800s. It is dedicated to St Llawddog. In the graveyard you will find a megalithic Ogham stone that still retains some of its markings and the memorial and grave of William Edmond Logan, a Canadian cartographer, who mapped the coal mines of Wales. The lighting inside of the church seems to have not only electric lighting, but also ornate oil or gas lamps along the aisle.

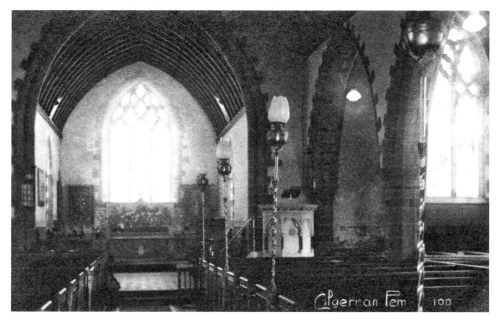

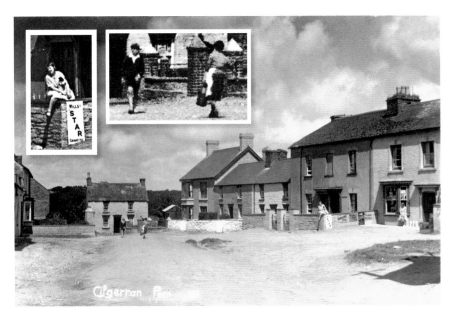

The sepia photograph of Cilgerran above was also produced in black and white, as can be seen in the magnified insets taken from the same photograph. The three boys in the photograph below are dressed in their dai caps, knickerbockers and clogs. When I was small, clogs were still worn by a lot of people. They were made of wood with leather uppers and metal clackers nailed to the toe and heel to protect the wood. The men's clog boots used for work had more metal studs on the bottom. They were great to keep your feet warm and dry in the winter. In very hot summers when the tar melted on the roads it was less of a problem than wearing leather or rubber soled shoes. During the war, coupons weren't needed to buy clogs, whereas they were needed to buy rubber-soled shoes.

Welsh clog dancing has been a tradition for centuries. The steps are complicated, including tricks, leaping into the air and putting out candle flames.

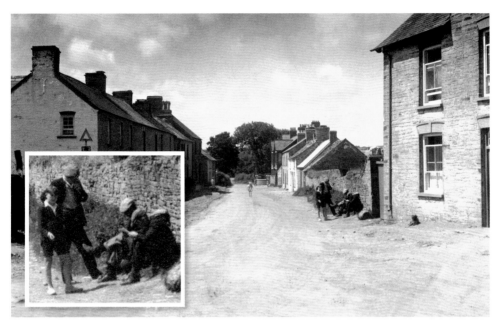

I wonder who the people in the photographs on these pages are? I talked to an expert on fishing in the River Teifi about the men in the photograph above and he thought they could have been picking out numbered tokens from the leather bag that determined which pool on the river they would fish that day. This was the way that ensured that the river was fished fairly. The man nearest in the enlarged photograph is holding a 'priest' (a stick with a heavy metal head attached to a metal or wooden base used to quickly kill the fish caught). The boy with the white collar walking past them seems to have been on the spot for many of Harry's Cilgerran photographs. In the right of the photograph below is a lady looking out at Harry. She appears in the magnified inset.

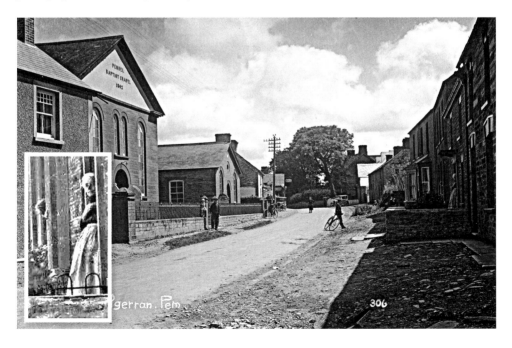

Cwmyreglwys

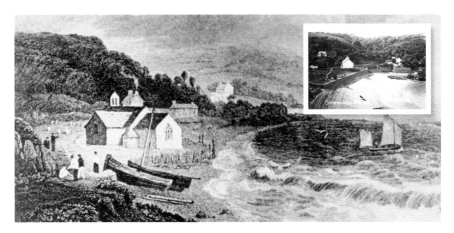

Cwm yr Eglwys means 'Valley of the Church' in English. Harry collected very old prints, including this one. It was certainly such a lovely setting that H. Gastineau drew the scene, E. Kennion engraved it and it appeared in *Wales Illustrated* in 1831 (Jones & Co.). As it was out of copyright in Harry's time, he bought it and used it to make this copy as a postcard of Cwmyreglwys. It provides us with an impression of what a picturesque village it was prior to 1859 with the twelfth-century St Brynach's church in prominent position right by the sea.

On 25 and 26 October 1859, the worst storm of the nineteenth century hit the country. The devastation in Cwmyreglwys was so great that St Brynach's church was destroyed, leaving just the remains in the photograph below. The inset photograph above shows the buildings that remained in Harry's time. My grandma told me that locally it was known as the great storm. Countrywide, the storm was known as the Royal Charter Storm, after the name of the ship of the same name that was wrecked near Anglesea, losing more than 450 people. This prompted the beginning of our weather forecasting system.

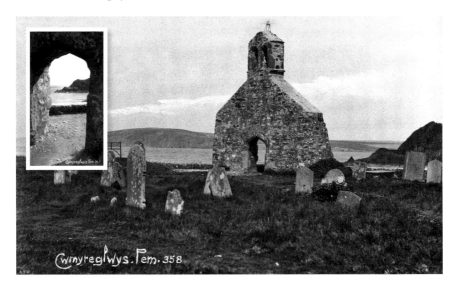

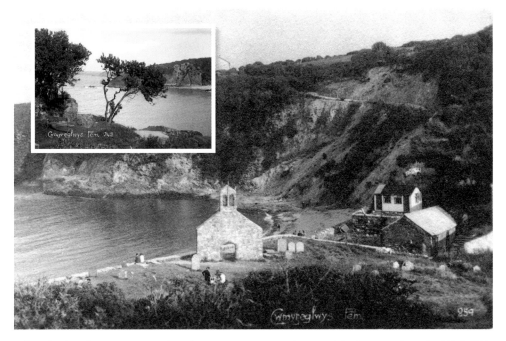

A hundred and twenty years after the great storm, another one hit Cwmyreglwys in 1979. This removed many of the stones you can see that remained when Harry took the postcards on these pages and damaged the church further. Despite these awful disasters, Cwmyreglwys is still there and a beautiful place to visit.

Harry often added to the beauty of the scene with his bathing belles. The young ladies in the photograph below were my aunt and her friend.

When you visit Cwmyreglwys, do take the circular walk from the village around Dinas Head to Pwllgwaelod and back inland through the valley to Cwmyreglwys. It is a must, especially on a sunny day.

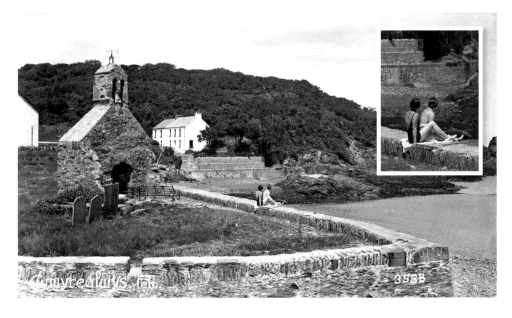

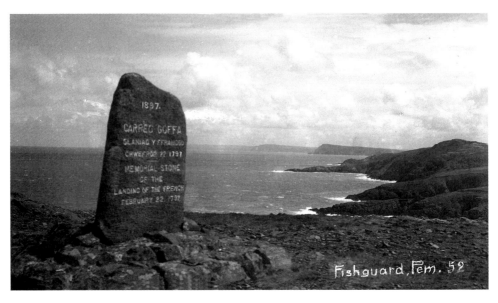

Fishguard.Pem. 52

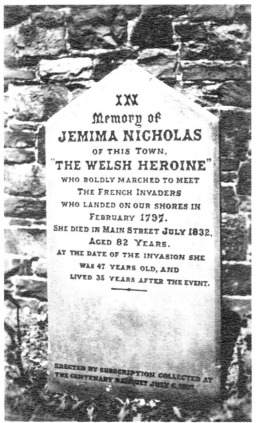

Fishguard is the site of the last unsuccessful attempted invasion of Britain in 1797 by the French. The story I learned as a child was that the French gave up when they saw figures on the headland with tall black hats and red cloaks, and thought they were soldiers, when they were in fact local women wearing their customary tall black Welsh hats and red woollen cloaks.

There was also the heroine Jemima Nicholas who had, with her pitchfork, 'encouraged' twelve of the French soldiers to go into St Mary's church and locked them in. The Welsh women were as keen as the men to protect our country from invasion and did it very successfully.

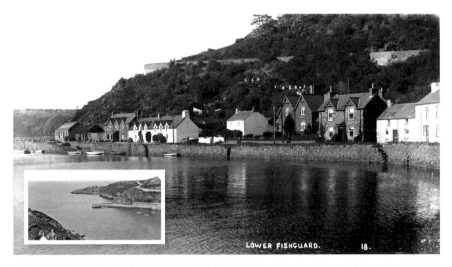

LOWER FISHGUARD. 18.

The old harbour in the lower part of Fishguard looks very contained and picturesque in the photograph above. When viewed from the other side of the bay in the inset photograph, it looks bigger than it may at first have appeared. On the headland that juts out into the sea in this inset photograph is the ruin of the old Fort, which was built in 1781. It was on this headland that the ladies of Fishguard marched and fooled the French invasion force into thinking they were soldiers.

It was decided that the old harbour was not of sufficient size to cater for the larger vessels that came into port at the beginning of the 1900s and a new larger harbour was built. The 'new' Fishguard Harbour opened in 1906 in Goodwick. It became the ferry terminal, offering a better link between Wales and Ireland, joining the Great Western Railway (GWR) with the Fishguard and Rosslare Railway (see inset photograph of the railway in the harbour). The link across the channel was made by the City of Cork Steam Packet. It all made for a speedier link for trade and was a time of great development for Fishguard and Goodwick with ferries sailing from the harbour to and from Rosslare, Cork and Waterford.

30. Fishguard. Fem.

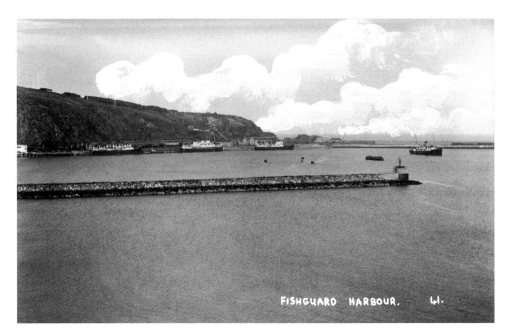

FISHGUARD HARBOUR. 41.

In the postcard above, Fishguard harbour looks busy, with three ships in port. The one in the centre with two funnels may have been the *Innisfallen*, which regularly sailed from Fishguard to Cork and back. Perhaps someone can identify some of the vessels. In the distance is the 'new' harbour wall jutting out into the sea.

The Fishguard Bay Hotel can be seen in the postcard below. It was formally known as the Wyncliffe Hotel until the Great Western Railway bought it and developed it. It has provided a rest home for First World War and Second World War officers, and accommodation for film crews working on the films of *Moby Dick* and *Under Milk Wood*. The hotel is still providing accommodation for travellers today. Currently there are two ferry crossings a day throughout the year to Rosslare.

49. Fishguard, Pem.

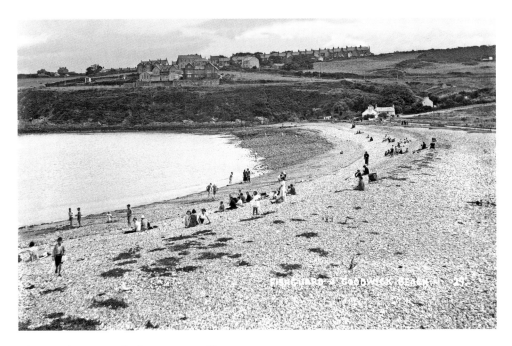

Above is the postcard of Goodwick with people enjoying the beach despite the lack of sunshine. It's still a good place to watch the ferry leaving. A close look at the clouds in these two photographs demonstrates Harry's decision to add interest to a very dull sky by drawing clouds onto the glass plate before developing it.

If you walk along the coastal path heading north from Fishguard, you will have wonderful views of the rugged coastline. Not long before you reach the Fishguard Bay Caravan Site & Camping Park, keep looking down to the sea and you will come across the Needle Rock below you. Harry's photograph was taken at sea level from his boat.

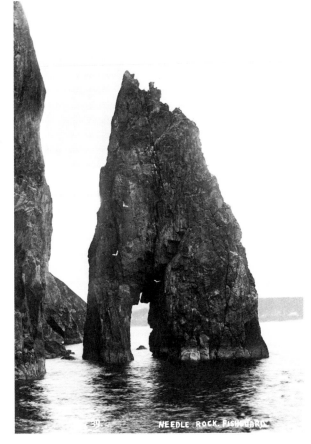

Glogue

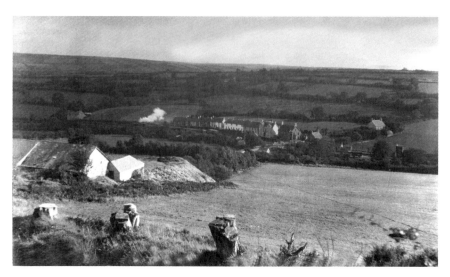

Glogue is a very small village that, according to my dad, had a slate quarry that was still being worked when he was a teenager but had closed in 1926. In fact the quarry at one time was one of the largest in the area. Now it still provides stone for building purposes in this part of the county. Harry's notes indicate that the photograph above shows the quarry buildings overlooking the village, with the face of the quarry hidden in the cliffs that fall away from the site of the work buildings. This wasn't one of Harry's usual picturesque postcard photographs and appears to have been taken as one of a set for the quarry owner, a Mr John Owen, who had invested in the surveying and navigation plans for the building of the Whitland & Taf Vale Railway, which ran through Glogue. He wanted the connection to increase his opportunity to connect his quarry with the outside world and increase sales opportunities. The plan was a success and the line opened in 1873.

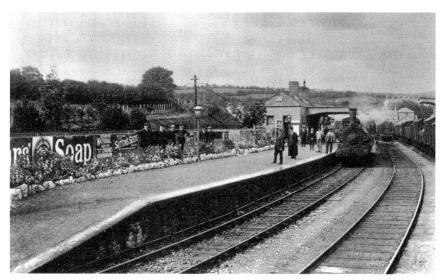

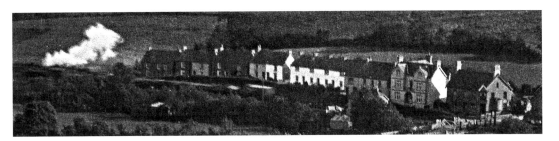

Mr Owen increased his workforce, employing more than eighty men. It was a very dangerous job but was worked for more than 100 years, providing better pay than agricultural work.

In 1886, the line was extended to Cardigan and its name changed to the Whitland & Cardigan Railway in 1877. However, locally the line and train were known as the Cardi Bach (Little Cardi). The line ran through dramatic scenery and over very challenging gradients on its way up to Crymmych. It was an important link for communities and ran until Mr Beeching came along, axing rural networks and breaking all those well established links. The last passenger service ran in September 1962, followed by closure of the freight service the next year. I remember my trip on the Cardi Bach when I was very small. It was the first time I'd experienced travelling by train. The memory I have is that on our trip the train driver stopped the train near his house to pick up his lunch box from his wife. I don't know where along the line this was, but it obviously made an impression on me, as everyone hung out of the window to watch.

For me it was a brilliant find to see the train steaming along through Glogue in Harry's photograph. To show more detail, I have magnified two sections of the original photograph. The first one above shows the level crossing and water tank on the right and the Cardi Bach passing the houses.

The magnified photograph below shows the goods yard and water tower. A visit to Glogue this year (2014) showed what remained of the quarry and the area it covered. As I drove down along the road (past the furthest house on the right in the photograph below) the extensive face of the very steep high cliffs that had been quarried appeared towering above the quarry – a daunting place to have worked.

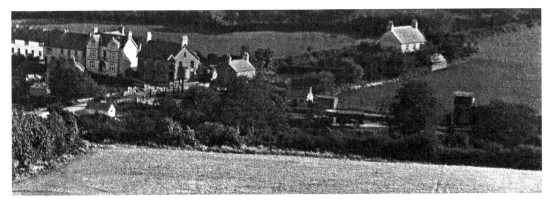

Moylgrove (Trewyddel) and Ceibwr

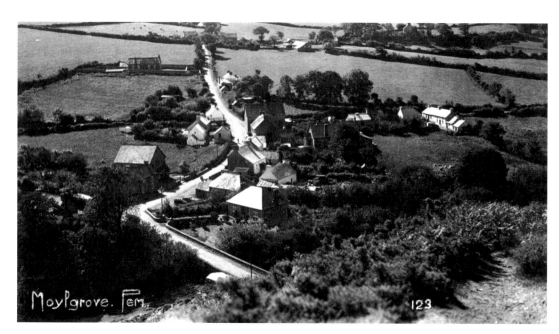

The small village of Moylegrove is in the Ceibwr valley that Nant Ceibwr (Ceibwr Brook) runs through down to Ceibwr beach and into the bay. Here the cliffs and coastline are quite spectacular. The part of the Pembroke Coastal Path that follows this part of the coast is well worth following.

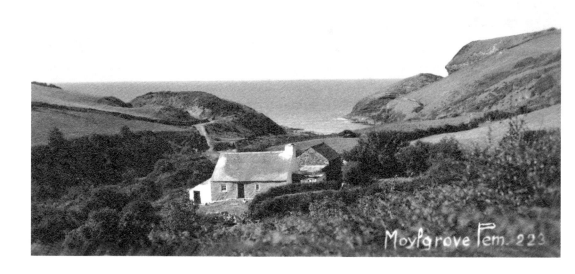

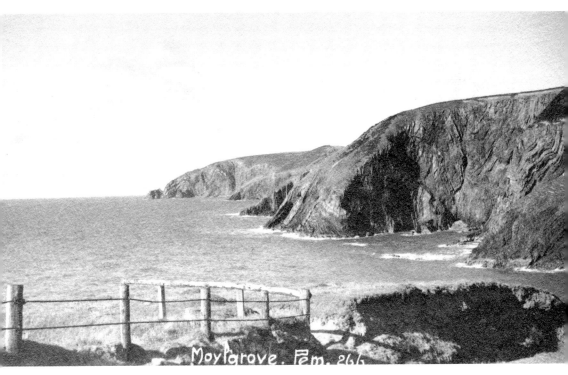

Ceibwr was close enough to walk to from my home. We did a lot more walking when I was young. A day out to Ceibwr with a picnic was a family favourite. We were often lucky to see Atlantic grey seals lazing on the rocks and choughs flying from cliff to cliff. Sometimes we saw bottlenose dolphins.

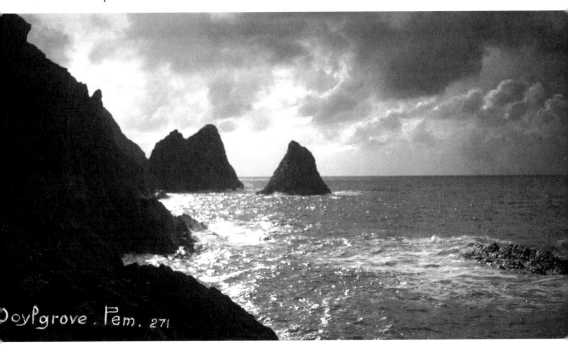

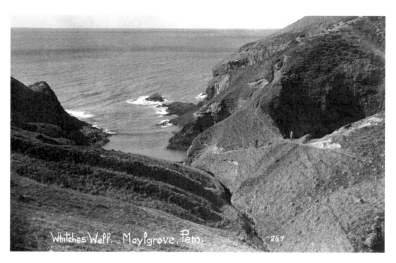

Whitches Well, Moylgrove, Pem. 267

Just a quarter of a mile south of Ceibwr along the cliff path, you will pass more amazing rock structures and come to the little cove with the massive cauldron-like hole in the rocks that Harry called the 'Witches' Well' (also known as the Witches' Cauldron). The size of the people on the rim of the cauldron gives an idea of its size. The cauldron was a cave that collapsed. At low tide, the sea laps through a hole in the rocks at its base onto a little beach inside the cauldron. In stormy weather at high tide, it is a different story and the sea can blast into the cauldron, through this hole and way up into the air with enormous force. The result of our recent great storms was evident in the cauldron, as the force of the waves blasting up through it had removed not only earth from high up, but also rocks that lay in a pile at the bottom. The cove is an amazing place to visit, with the stream surging down through the valley into and under the rocks and out to sea. Around September, sometimes Atlantic grey seals bring their pups into the cauldron beach.

For such a small place, there is a lot to see, including the huge 5-6,000-year-old Llech y Dribedd (Tripod Stone). Legend suggests that someone extremely strong (either Samson of Biblical times or St Samson of the sixth century) hurled the capstone from the summit of Carn Ingli and this was where it landed. I reckon many of us think it is a cromlech – a Neolithic burial chamber.

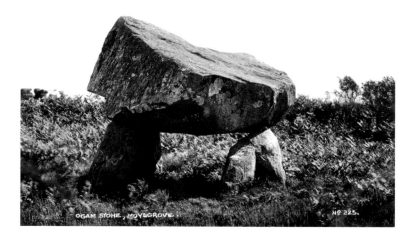

OGAM STONE, MOYLGROVE. N° 225.

Nevern (Nanhyfer)

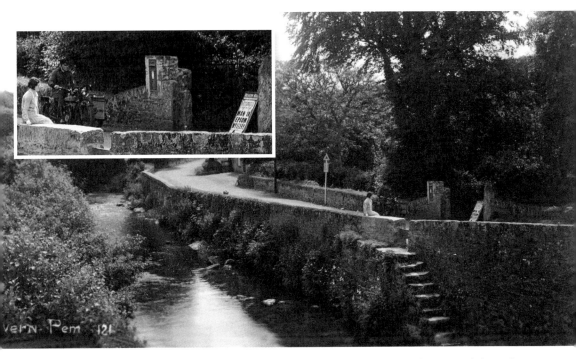

Nevern is very close to Moylegrove and somewhere that as a family we often passed through. Does anyone know the people in the photographs and what the notice on the board ('Man in Epsom Mystery') that the girl and postman are so interested in is all about?

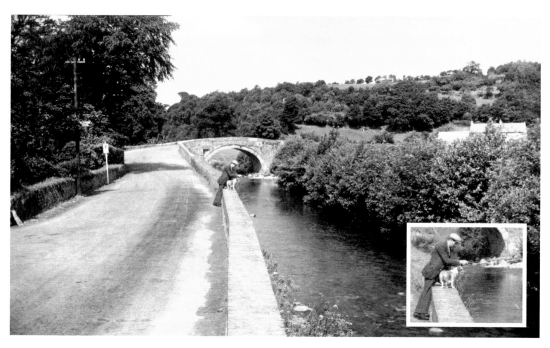

Wherever we went, Dad made sure he brought his fishing rod, as did the man in the photograph above. Nevern was a good place to catch trout and eels. On one rare special occasion, we stopped for a meal at the Trewern Arms to celebrate my mum and dad's wedding anniversary. It's behind the trees on the left of the photograph above. That was the place where I first tasted a delicious lobster thermidor.

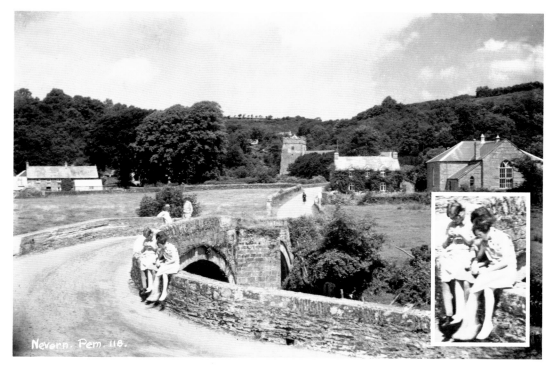

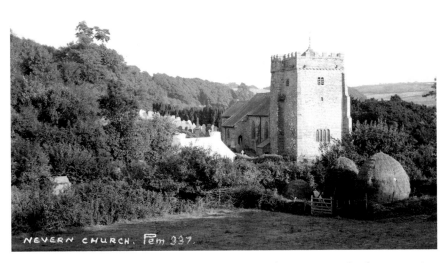

Nevern church fascinated me as a child, as I thought it contained a few mysteries. To be told that it had been there since the sixth century seemed very difficult to comprehend. Also, there was the strange bleeding yew tree in the grounds (it's still there). The runes on a window sill inside the church were exciting as they were to be seen and read if only you could break the code. At that time, I knew nothing about the motte-and-bailey castle ruins hidden amongst the trees on the hill behind the church. Just outside the church door is an enormous Celtic cross with markings I remember tracing with my fingers. The mounting steps outside the church were fun to run up and down, and imagine what it was like to be the people who rode up to church on their horses and used them to make dismounting easier.

It was only on close inspection of the photograph above that I noticed the spectacular hay ricks in front of the church, which were made in a very different way to those to those we see nowadays.

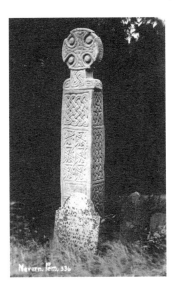

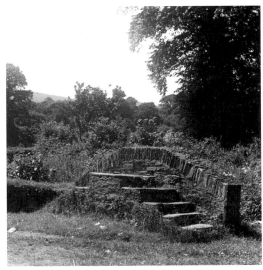

Newport (Trefdraeth) & the Gwaun Valley (Cwm Gwaun)

Newport came into being around 800 years ago when William Fitz Martin set up the town as a capital of Cemais following his ejection from his base in Nevern by Lord Rhys, his father-in-law. Little of the original castle remained, and what you see in both of the following photographs is now a private home that was built by Sir Thomas Lloyd in 1859 on the site of the gatehouse, which was demolished. The three-storey house was incorporated into the remaining three towers that form the corners of the building and curtain wall. In the photograph below, I have inset a magnified section showing the man with his dog cart walking up the lane towards the castle. He may have been delivering groceries. The lane is very steep and it would be hard work carrying goods without the help of a dog cart. The large paws showing underneath this cart suggests that this dog was big, and it looks like the man might be helping by pushing the cart.

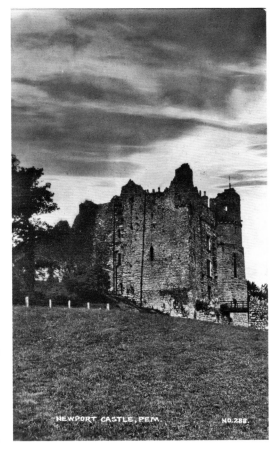

Here's another view of the castle. It was rented by John Brett, the Pre-Raphaelite artist, back in the 1880s. He would moor his schooner, *Viking*, at Parrog and then in the summer sailed off painting, photographing and sketching the coast of Wales while his family stayed in the castle. In the winter I believe he sailed around the Mediterranean.

The view from the castle over Newport and the Nevern Estuary is lovely, as Harry's photograph below demonstrates. When it was taken, the tide was out and the River Nevern can be seen snaking out to the sea.

Newport continues to keep its borough custom of electing a mayor. He or she then goes around the town on horseback every year in August 'beating the bounds'. This is one of the customs that dates back to the 1600s when Newport was one of the five marcher boroughs of Pembrokeshire and watched over by a portreeve. The portreeve was the port warden who had authority over the town.

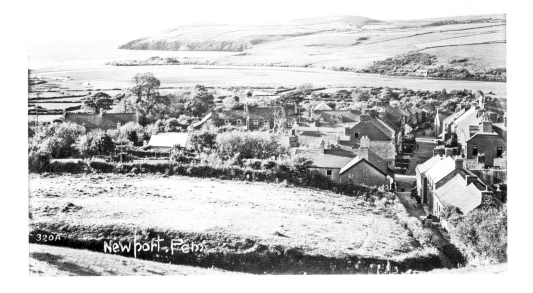

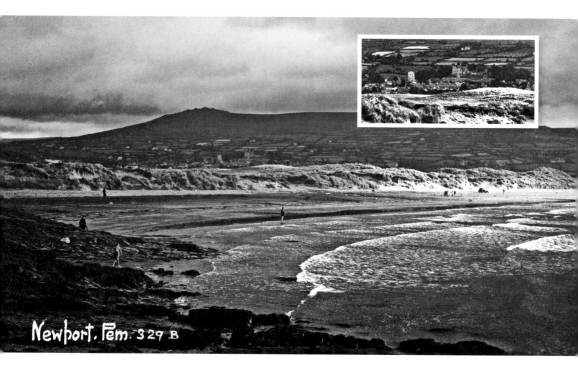

Newport. Pem. 3 29 B

Newport (Trefdraeth) has been and still is a popular place for holidaymakers. The Welsh name means 'town by the beach' and there are four beaches to enjoy. It's a friendly town situated below Carn Ingli mountain (Mount of Angels).

The name Carn Ingli may have come from the fifth-century Saint Brynach's habit of climbing to the top to chat with angels. But then this would have been Carn Engylau. Your climb up to the top offers amazing views of the countryside together with evidence of a Stone Age hill fort and stone circle remains of the huts of people who had lived there during the Bronze Age (Figgis, 2001). On either side of the Nevern river are the mile-long Newport (Traeth Mawr) in the photograph above. The inset photograph gives a glimpse of the town nestled behind the dunes. On the other side is the Parrog in the photograph below. This was the old port.

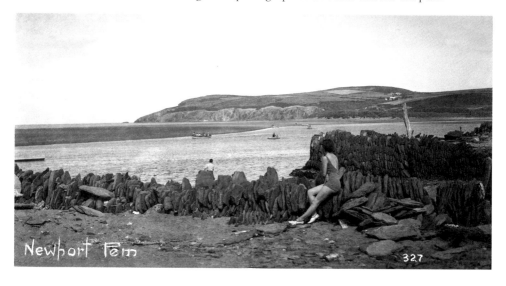

Newport Pem 327

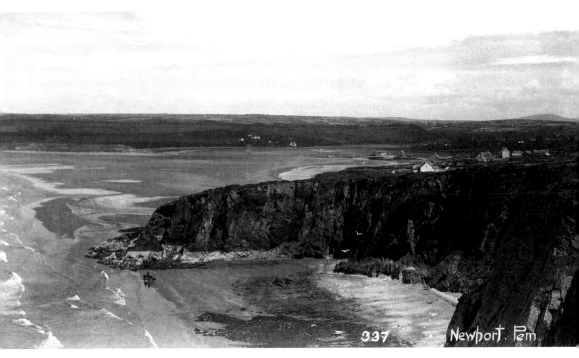

If you walk along the coastal path past the houses that run alongside the Parrog, you'll come to two more beaches. These are the Cwm and Bettws beaches. The Cwm Beach (Valley Beach) is the first you will come to after Parrog. It is tiny and behind the headland in the photograph above. It gives a good view of the Nevern estuary and southern end of Traeth Mawr (Big Beach). You'll pass the old lifeboat station on your way. It is still there, although now a private property. It was only used for the eleven years after it was built until 1895, perhaps because of the dangerous currents produced by the nearby sand bar where the River Nevern flows out into the sea. This is dangerous for swimmers when the tide goes out. These two photographs are of Bettws Beach.

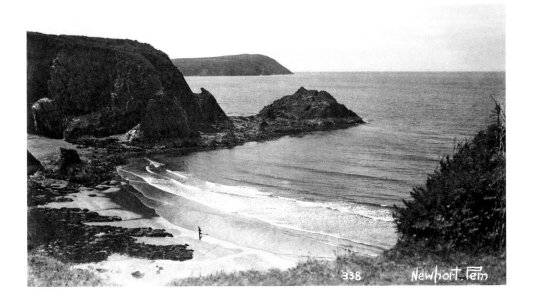

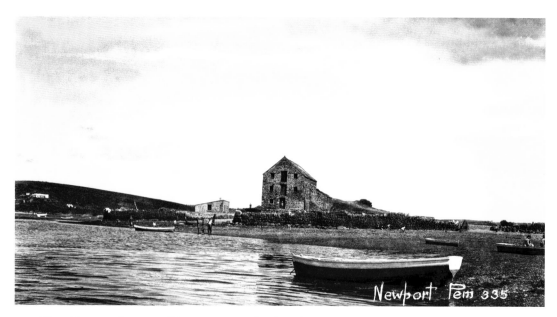

The old port at Parrog still has remnants of its long history, including the old warehouse (in the photograph above). It now functions as the Boat Club where, at the time of writing, you can get a drink even though you may not be a member of the club, as it has a non-members' bar. Look out for the lime kiln along with the original walls of the quay.

It is quite a strange thing to see my grandmother as a young woman standing by the warehouse in the photograph below. She's looking out towards Parrog across the water. When the tide is out you can cross the River Nevern from Traeth Mawr to Parrog beach at the shallowest part. This is called 'The Chain'. Check with a local to find it. This is best done in your swim suit or with your trousers rolled up to avoid getting very wet. It is possible to cross further down the estuary, close to Parrog at the widest part of the river, but only at low tide.

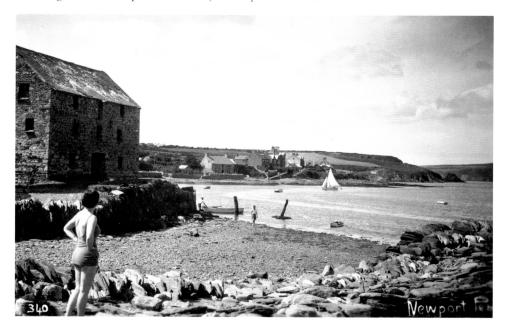

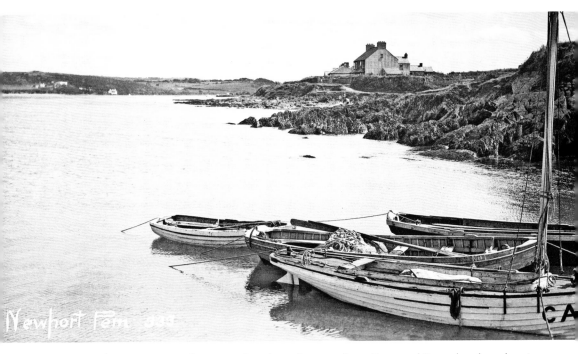

This view is the one you see when returning along the coast from Cwm and Betws beaches, showing the coast towards Parrog.

Harry particularly enjoyed capturing sunsets, as he did in the photograph below. Sunsets from Newport looking out over the sea can be truly lovely even on an evening prior to a change in the weather.

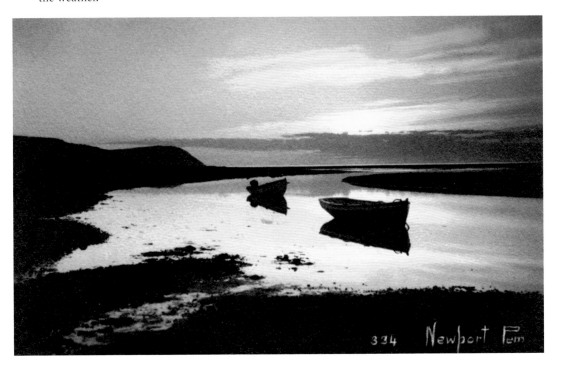

The Gwaun Valley (Cwm Gwaun) is a must if you stay in the Newport area. Sadly, I only have a few of Harry's photographs of the valley. The one above in the depth of winter reminds me of the New Year when I was a child. I had a clear idea that the Gwaun Valley was a very different place that seemed to be remote and secret. Like most areas in our part of the world, we children looked forward to New Year's Day when we visited all our neighbours (avoiding the unwelcoming ones of course). It was time to wish them 'Blwyddyn Newydd Dda' (Happy New Year), hoping to get calenig (a New Year's gift). I reckoned that singing a song followed by 'Cofiwch y calenig' ('Remember the New Year's Gift') would result in a better gift. I liked to sing 'Calon lân yn llawn daioni' ('A pure heart full of goodness') and remember getting a silver thrupenny piece – a lot of money when I was very small. I think we were all pleased to get anything (like a sweet, an apple or a farthing), knowing that everyone had very little to offer then. I remember my dad telling me that the children living in the Gwuan Valley had a different New Year's Day to us because back in the 1500s when the rest of the world started to use the Gregorian calendar, in the valley they continued to use the Julian calendar. So they collected calenig on 13 January while we did on 1 January. I often thought it might be a great place to live if you could have two New Year's Days.

Pembroke & Manorbier

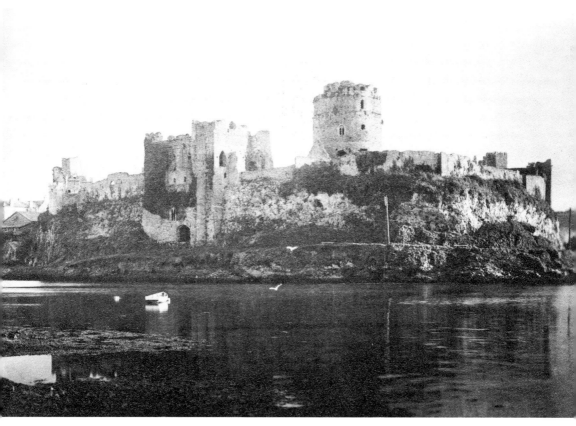

I have included both Pembroke and Manorbier together, as they are close to each other geographically. Also, as the two places were in Harry's brother's area for postcard production, I've included work produced by both of them. The postcard above was Arthur's, as were the two postcards of Manorbier, while the etching of Manorbier Castle was Harry's (*see overleaf*).

Pembroke Castle is particularly interesting, as on the banks of the river below is a cave called Cats Hole Cave that was excavated back in 1906. The finds indicated that it was occupied by hunter gatherers who lived sometime before the last ice age. This was based on dating the human bones and tools found there together with mammoth, wolf, bear and hyena bones found deep down in the cave. More recently, the first building to appear on the sight might have been a fort made of timber and earth built by Arnulf of Mongomery in the eleventh century. This was followed by stone walls being erected by William de Valence in the eleventh century to keep the town safe.

It was in 1457 that the town became really important, when Henry Tudor was born in the castle. Like many towns in the area, the Middle Ages brought prosperity until the Civil War, when Cromwell conquered the castle. Now Pembroke Castle is managed and owned by a private charitable trust and well worth visiting, not only for its history, but also to enjoy the great views across towards Milford Haven. I believe it even has a Brass Rubbing Centre. Pembroke is a town that not only has history to interest you, but lovely beaches to relax on.

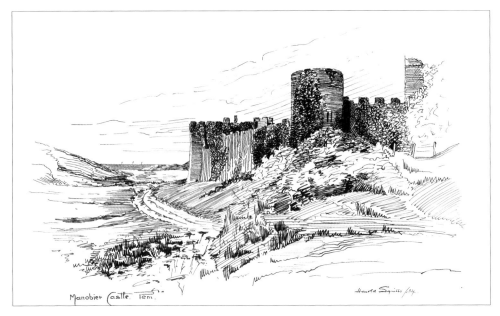

Manorbier Castle is yet another Norman building and its timeline of developments is similar to those of Pembroke Castle. This one was built by Odo De Barri, who received the land for helping conquer this part of Wales. He first built a keep made of timber, encircled by earth embankments ,in the late eleventh century. This was fortified in the next century by his son William with stone walls. Odo's grandson, the scholar Geraldus Cambrensis (Gerald of Wales), was born in the castle. He toured Wales back in 1188 with the Archbishop of Canterbury, and wrote two books about the experience (*Itinerarium Cambriae* in 1191 and *Descriptio Cambriae* in 1194). He remarked that, 'In all the broad lands of Wales, Manorbier is the most pleasant place so far.' The views from the castle are quite lovely, as you can see in Arthur's postcard (*inset*).

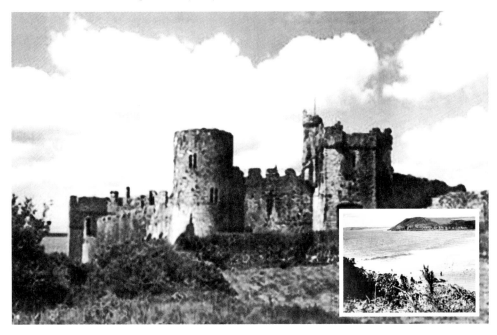

Porthgain & Preseli Mountains (Mynyddoedd y Preseli)

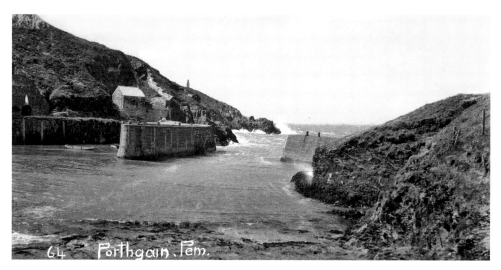

64 Porthgain. Pem.

Porthgain is an interesting and sheltered little port, and back in the 1800s and early 1900s it was a hive of activity. The people who lived there worked in the slate and brick industry, either quarrying or making bricks. Some of their cottages are still there, dwarfed by the huge brick hoppers where the crushed rock was kept, before being loaded into ships for transportation. I've learned that the rock quarried near here was Preseli Spotted Dolerite and is harder than granite.

For the first time in many years, I went down to the village recently and found it to be still a hive of activity, but of a much more pleasant nature than it had been in the past. Now it's popular with tourists and the pub, now called the Sloop, still provides good food and drinks.

There are tales of the water from the well in the photograph below curing warts. Trying to get your hands in the water is quite a challenge. I reckon it's better to go walking there to enjoy the stunning scenery.

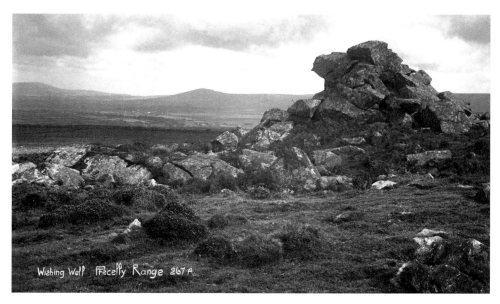

Wishing Well Frecelly Range 267A

Pwllgwaelod

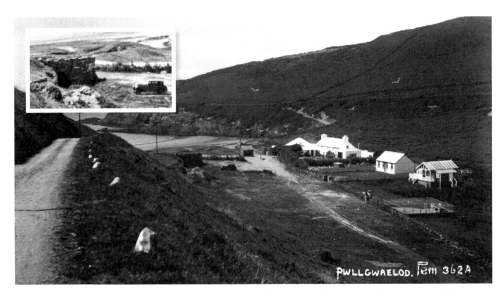

Pwllgwaelod is yet another of the many beautiful little beaches in Pembrokeshire. The larger building in the photograph is currently a bar and restaurant called The Old Sailors. Harry's research into the history of the inn suggested that it used to be called the Sailors Safety and was very old, dating back 400 or 500 years. In olden days it always had a guiding light in it to help ships find their way into the cove.

Like many of the South West Wales bays, Pwllgwaelod still has a lime kiln, where the limestone that the ships brought in was burned and changed into quicklime. They were built in the early 1800s to deal with the limestone that was brought by ship into the bays. This one is in the car park near the Old Sailer's Inn and Restaurant. You can just see it to the left of the car in the car park, and in a bit more detail in the magnified inset in the photograph above.

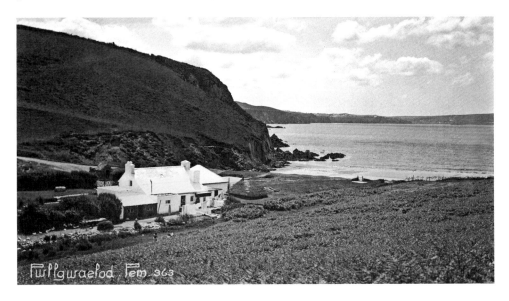

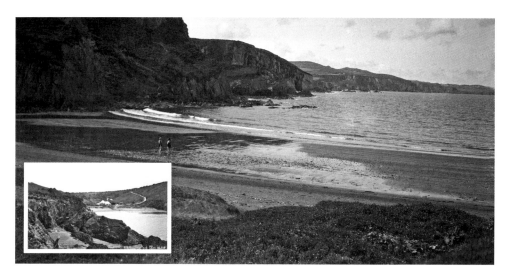

In the past, when storms came in from the east and the strong winds made Fishguard too dangerous for ships to enter the harbour, they would shelter in Pwllgwaelod until the storm passed. In the Admiralty Hydrographic Department's 1870 publication, they wrote that Pwllgwaelod was 'within Dinas head, and almost insulates it. This beach has better shelter than that of Goodie (i.e. Goodie Sands by Fishguard).'

When I was little, my grandma told me a story (which I've since found was written back in 1905 by Sabine Baring-Gould) about an underwater fairy city off Dinas Point. On calm, clear days, sometimes people in the village would catch a glimpse of the golden roofs, spires and palaces down under the water. One day, a fisherman from Dinas anchored his boat over the city and had a bit of a shock when one of the sea people popped up next to him, and said, 'What is this that you are doing? Your anchor is in the roof of my house.' The problem was resolved when the captain promised to remove the anchor and avoid mooring there again. I think the author may have got the idea from the legend of the ancient lost kingdom Cantre'r Gwaelod (Lowland Hundred), which was believed to have disappeared under the sea in Cardigan Bay and the bells ringing below the sea can sometimes be heard. The song associated with the legend 'The Bells of Aberdovey (Clychau Aberdyfi)' was one we all learned in school. It was first sung such a long time ago in 1785, in an English opera called Liberty Hall.

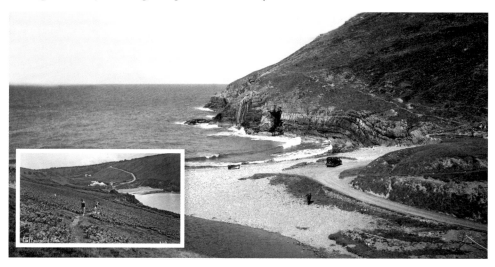

Saundersfoot (St Issells)

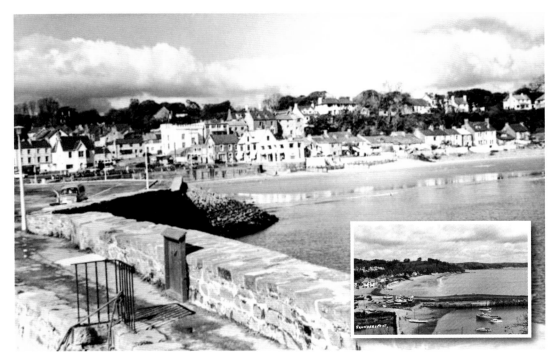

In medieval times, Saundersfoot was known as Llanussyllt. The name changed after the Norman conquest to St Issllis (or St Issells) after Saint Issell's church, which was named after the Welsh saint of the same name.

The harbour was built in the early 1800s to export anthracite coal mined in the area. Prior to this, the coal was transferred to ships on the beach. Five jetties had been built by 1837 and materials that passed through the harbour included not only coal but also iron ore, pig iron and firebricks. Handling these was made easier when the Saundersfoot Railway and Harbour Company built the tramway that led to the jetty.

Now the industry has disappeared and Saundersfoot is a small blue flag seaside resort. The Pembrokeshire Coast National Park has designated it as a conservation area. You can take a boat trip or try out the Battlefield Live, which is apparently like paintballing but with lasers (so no bruises). Of course, Saundersfoot is close to all of the other interesting places in Pembrokshire to visit.

St Davids (Tyddewi) & Whitesands Bay (Traeth Porth Mawr)

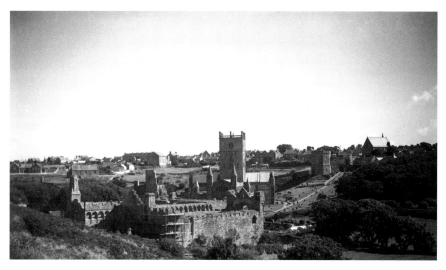

St David's (Tyddewi) is the smallest city in Britain and has such a lot to offer. Not only is it small enough to still look like a small town rather than a city, but it has a magnificent twelfth-century cathedral and the beautiful coastline with its spectacular beaches like Whitesands Bay.

St Davids is named after our patron saint, St David. His parents were St Non and a Ceredigion prince. He set up a monastery where St Davids Cathedral stands now, and, with his followers, led a simple life as a vegetarian, avoiding alcohol. On St David's Day on 1 March, we wear his symbol, a leek or a daffodil. He became a bishop and one of his pilgrimages took him to Jerusalem, where he acquired a stone that is still in the south transept in the cathedral.

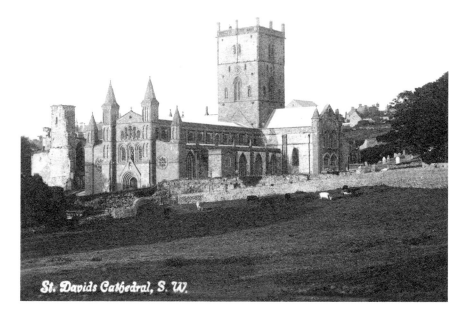

St. Davids Cathedral, S. W.

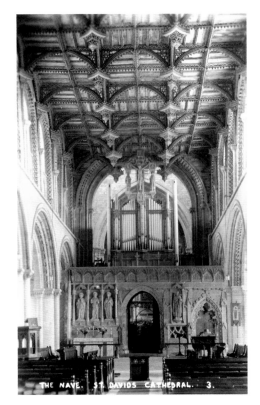

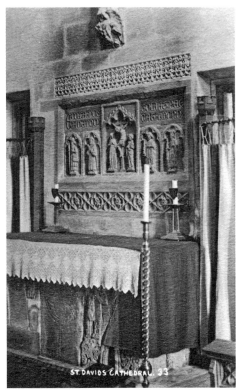

The sepia postcards with serial numbers 3 and 4 were two of a set of six or more that Harry was commissioned to publish, which I believe were sold in the cathedral and stores in St Davids. The black-and-white one numbered 33 was one of the same set, but I believe was produced later as part of the same set and renumbered.

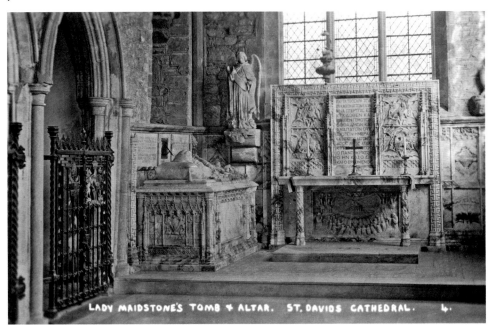

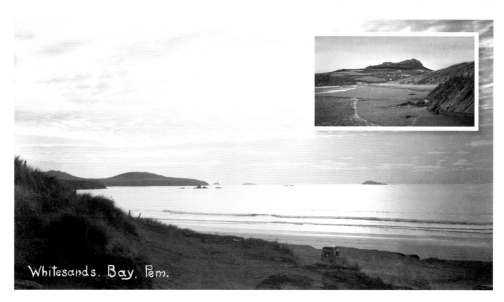

Whitesands Bay (Traeth Porth Mawr) is part of the Pembrokeshire Coast National Park and found on the St David's Peninsula just about 2 miles away from St Davids. It's great for surfing, very popular with tourists and of course the coastline is quite beautiful. The bay has been awarded the Blue Flag EEC standard.

In the inset photograph above and to the north of the bay is Carn Llidi (Cairn of Wrath), which is the highest point in the bay. In this area and around St Davids Head, there are hut circles, Iron Age field systems and megalithic burial chambers to look out for. There are also the secluded bays of Porthmelgan and Porthlleuog to find if you follow the Pembrokeshire Coastal Path north. The scenery here becomes rugged as you reach St Davids Head, and from here you can look across to Ramsey Island (Ynys Dewi in Welsh, meaning 'David's Island', in recognition of our patron saint).

If you walk along the Pembrokeshire Coastal Path towards Whitesands, you will pass St Justinian's, St Davids lifeboat station. The land that it looks out onto in the photograph below is Ramsay Island, and the sea around here has very fast currents called the Bitches.

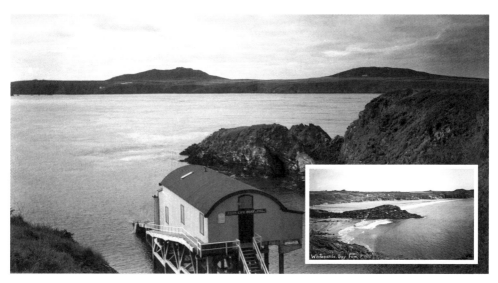

St Dogmaels (Llandudoch) & Poppit Sands (Traeth Poppit)

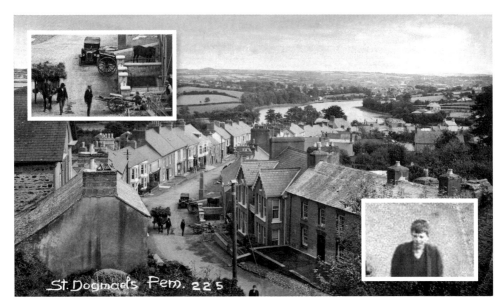

St. Dogmaels Pem. 225

Lland'och (St Dogmaels) is the village where I was born, grew up and am lucky to continue to return to. Many of us have had to leave home to find jobs, but still find ourselves returning 'home' if only for short stays. I remember Mr Jones, our headmaster, telling us that Llandudoch used to be the largest village in Wales, mainly due to its close proximity down river from Cardigan with its busy port and shipbuilding industry. Many master mariners had second homes in the village, as was the case in the house my maternal grandfather bought. The previous owner liked to see his ship sail up the river from the window when the pilot boarded to navigate the ship up to Cardigan and he was dropped off in St Dogmaels. It certainly is a beautiful place to live.

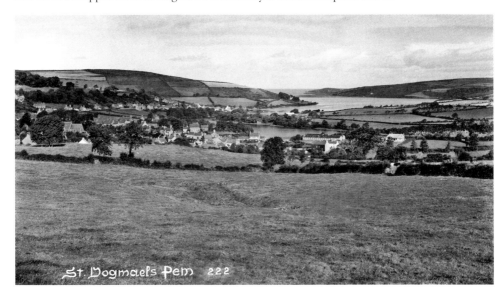

St. Dogmaels Pem 222

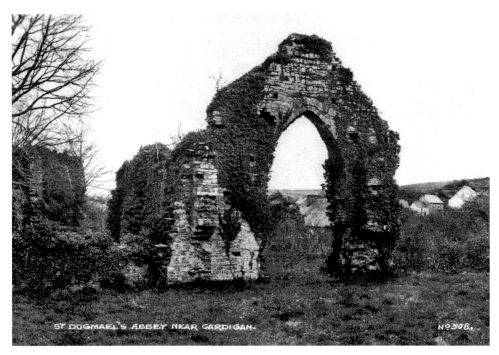

In the early twelfth century, St Dogmaels must have been quite an interesting and busy place, as this was when Robert Fitzmartin gave the Tironen Order money and land to build a monastery that developed into St Dogmaels Abbey. It was built on the site of a Celtic church (a clas) that dated back to *c.* 600 AD. As can be seen in Harry's photograph above, in his time the ruins were not cared for as is the case now. There is information about the history of the abbey at the Coach House Community and Visitors' Centre, where you can also visit the museum, shop and café. Across the road is the very old working mill, where you can learn how it works and buy the flour produced there. In its heyday, the abbey owned vast amounts of land and was important. Next to the abbey is St Thomas' church.

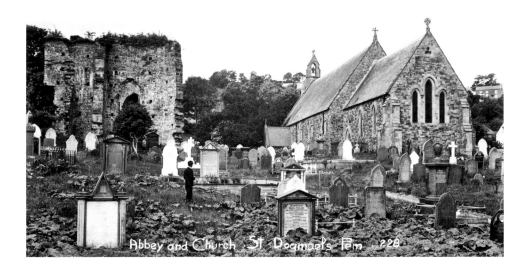

Above is the Jubilee carnival parade in 1935. Below is the village postman and children. In the magnified inset below can be seen a gentleman called Billy with his donkey, Punch.

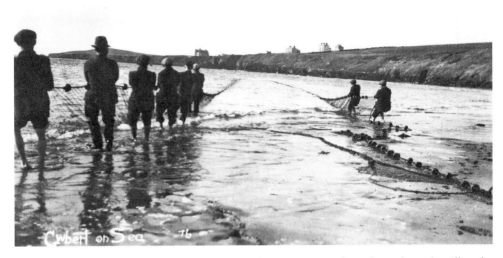

Seine net fishing has taken place in St Dogmaëls for centuries, and was brought to the village by the monks who set up the abbey in the village in 1118. It used to be a reliable way of making a living, with at one time about 150 men working on the sarn boats. Now I believe there are only a few crews.

The nets were laid at different pools up the river and at the estuary, as you can see in the photograph above. The net is very long with floats on the top and weights on the bottom, so that it hangs vertically in the water to trap the fish. While some of the crew held one end of the net, those in the boat cast it out as the boat circled back to shore. The fishermen on either side of the net pulled it in, bringing ashore the fish caught – usually salmon or sewen (sea trout). When I was young, the catches were large, as were the salmon caught, as you can see in the photograph below.

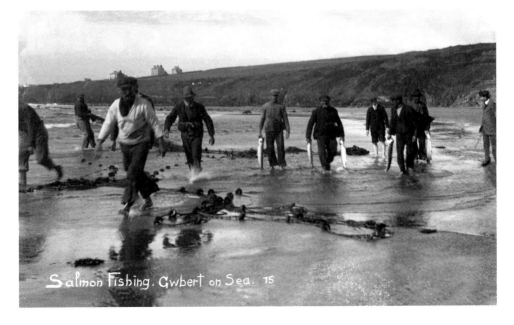

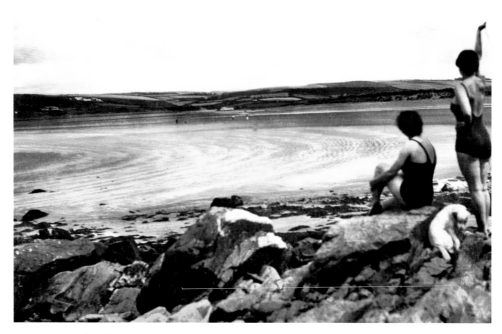

I was surprised to find this hand-painted photograph of my Auntie Joan and her friend with the family dog, Jack. It's not a very good example and I think it may have been one of Harry's sons' practice attempts when they were young, completed in the 1920s.

My childhood memories are of frequent family walks down past the Webley Hotel to the beach on the weekend, occasionally to fish, but often to gather driftwood for the fire. The walk and beach are still as pleasant as they were when I was a child, and you can still stop for a drink and a meal at the Webley. It's very pleasant to do that sitting outside on a sunny day looking out at a view of the estuary. However, they don't sell petrol there anymore.

Webley Hotel. Poppit. Sands Pem. 258

Poppit is still as special a place to come for a holiday, to take a walk, breathe in the fresh air and gaze out at the sea as it was in Victorian times, as the people in the photograph above are doing. The rocks the three young men are sitting on are known as the Black Rocks. The view in the postcard below from the beach across to Cardigan Island and Gwbert is rather special too.

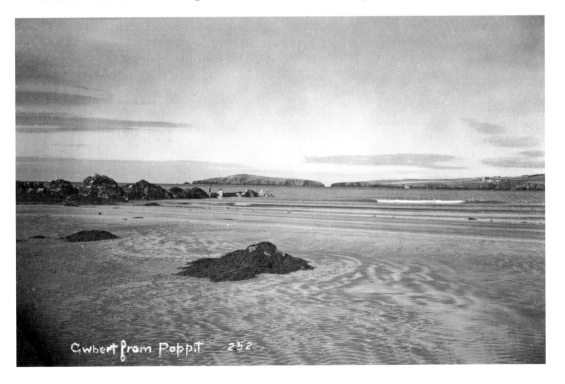

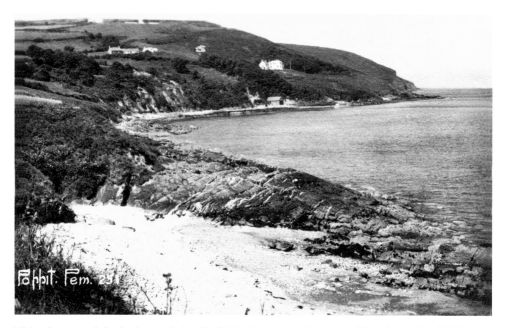

This photograph looks beyond the Black Rocks, across the second beach to the old lifeboat house, which can be seen on the shore in the distance. Our new lifeboat house is almost right on the main beach, so you can be sure you're safe when swimming.

Not so long ago, an ancient enormous fish trap was found in the shallow waters in the photograph above. It is 'v' shaped, made of rocks and measures about 260 m (853 ft) long. It is believed to be at least 1,000 years old, and would have been used to trap sewen (sea trout) and salmon that migrate up the River Teifi. It's under about 12 ft of water now, but the sea level would have been lower all that time ago. You can see it on Google Earth (Tivy-Side, 2009).

Being on the beach doesn't mean there's no work to be done. These two gentlemen have gravel to gather for building.

St Govans (Gofan) & Strumble Head (Pencaer)

Further down the Pembrokeshire coast there are yet two more interesting places to visit. The first is St Govan's chapel. You need to be prepared to clamber down the steps through the rocks to the chapel that's right by the sea. It's named after a hermit, St Gofan, who lived in a cave in the cleft in the rocks. The chapel was built there around the thirteenth century. There are many different stories about Gofan that include his being a monk from Ireland, a thief, being attacked by pirates and saved by angels, or being able to hide in a gash in the cliffs that magically opened up for him. No one really knows the truth of the matter. Count the number of steps on the way down and on the way back up to see if you get the same number. Has anyone managed to get the same number yet?

Then, of course, there is Strumble Head. This is where you'll find the Strumble Head Lighthouse, perched on top of St Michael's Island (Ynysmeicl). This has always been a great place to see Harbour Porpoises and Atlantic Grey Seals. Also, there are an amazing number of birds to be seen, including different types of shearwaters, skuas, gulls and terns, to name but a few.

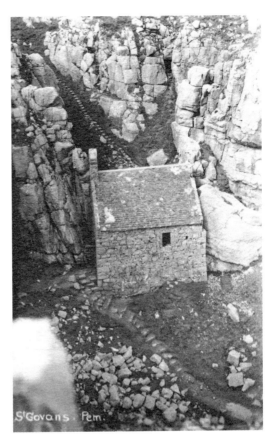

St Govans. Pem.

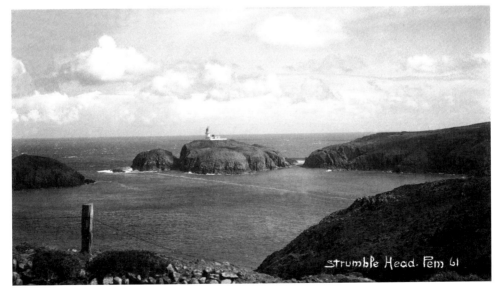

Strumble Head. Pem 61

Stack Rocks (Elegug Stac)

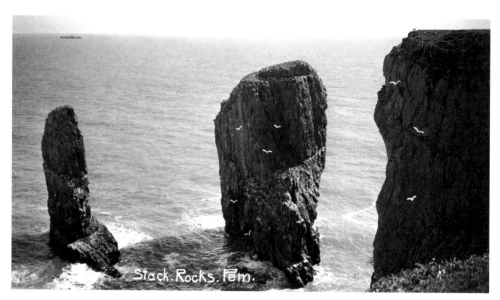

Stack.Rocks.Fem.

Following the theme of birds, Stack Rocks is a must for you if this is your interest. The top picture shows three of the carboniferous limestone stacks. These are the nesting sites of kittiwakes and guillemots. You will need to go onto the Castle Martin site to get to Stack Rocks, so it is worth checking to see if the road is open by checking their website (*see website references*). Locally, Stack Tocks are called Elegug ('Guillemot') Stacks. While there, look out for the Green Bridge of Wales, which is a spectacular limestone sea arch. One day it will collapse and leave the rock standing in the sea, free of the land, to become another stack. Don't leave it too long before seeing it, as there's no telling when the arch may disappear! The photograph below provides a closer look at the tightly packed seabirds on top of the middle stack, which is viewed from a different angle from the one above.

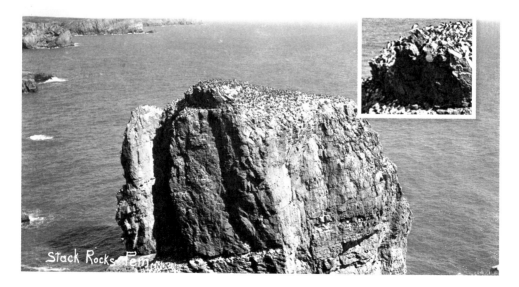

Stack Rocks Fem.

Tenby (Dinbych-y-pysgod)

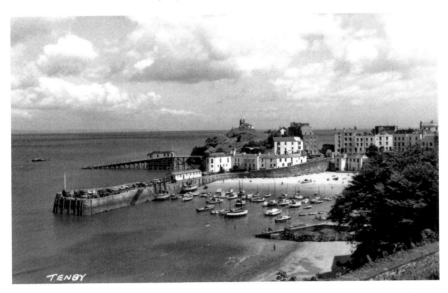

Tenby was the town where Harry's brother Arthur set up his Squibbs Studio, so the postcards of Tenby are his. When Arthur passed away in 1954, the business was bought by Mr Hughes, who continued to operate it under the name Squibbs Photographic Studios until he retired.

The town is right on the coast with two lovely, long, sandy beaches to enjoy. Dinbych-y-pysgod, the Welsh name of the town, means 'little town of fishes'.

Tenby is a very old walled town dating back to medieval times and beyond – perhaps as far back as the ninth century, when a poem called 'Etmic Dinbych' was thought to have been written. It was included in the *Book of Taliesin* that appeared back in the fourteenth century. The wall was built around the thirteenth century, and you can still see the Five Arches fortified gatehouse into the old town in the photograph on the next page.

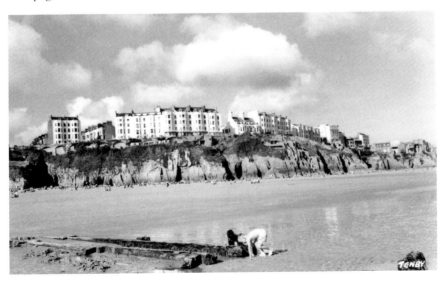

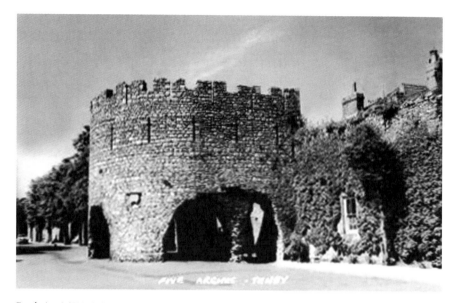

Back in 1471, King Henry VII stopped in Tenby on his way to exile. As a result, the town received money in the form of royal grants that were used to strengthen the walls and harbour. At this time, Tenby became an important port, with traders coming in from Portugal (they brought the first oranges into the country), France and Spain. The more recent building to appear in Tenby was the Palmerston Fort on St Catherine's Island in 1867.

Tenby is a very popular place for holidaymakers. Once you've checked out all the interesting things to see in the town, pop down to the harbour and you can sail out to Caldey Island. On the island, you can walk to the lighthouse, visit the museum in the village post office, relax on the beach or visit the monastery owned by the Reformed Order of Cistercian Monks. The monks live a simple life, farming and producing home-grown products including ice cream, chocolate, shortbread, yoghurt, perfumes and hand lotions made from the wild flowers that grow on Caldey Island. If you don't get to the island you can buy these things at the Caldey Island Shop in Quay Street in Tenby.

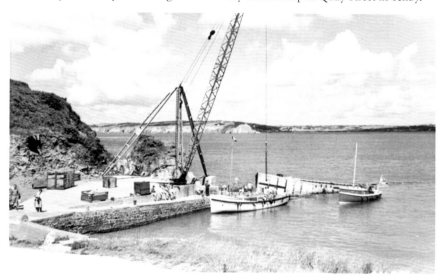

Trefain (Trefin)

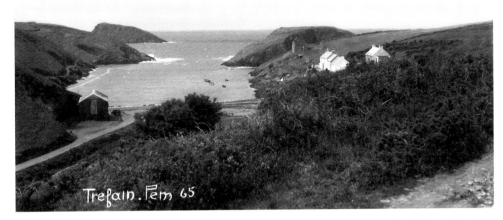

Trefin Village lies between Fishguard and St David's, and is a little way inland from Aberfelin Bay, which you can see in the postcards. The spelling of the name of the village differs from the one Harry has used on his cards. The original Welsh name was Trefaen, meaning 'the village on the rock'. It is from this name that more recent spellings of the name have arisen, like Harry's version, Trefin, and the Anglicised version, Trefine, which appear on websites.

For such a small, remote and quiet place, Trefin has a long history dating back to at least the 1500s when a mill was built for the villagers in the area. It was used to grind wheat into flour for making bread, barley for feeding animals and continued to work until 1918. Dad was sure that it had originally been used as a corn mill. The small building can be seen on the left of the photographs and was still standing when they were taken in the 1920s. As time passed it fell into ruin, loosing its roof and parts of the walls. Last time I visited the cove, I was pleased to see that the large grinding stones were still there, and was pleased to learn that the mill is now being looked after by the National Trust. It was this mill that the arch druid, poet and bard Crwys described in his famous poem 'Melin Trefin'(Trefin Mill).

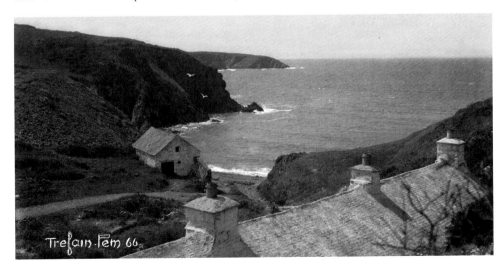

Velindre (Felindre Farchog)

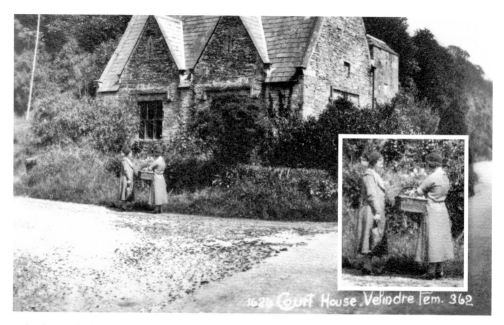

Velindre is a little village on the road from Cardigan to Tenby by the River Nevern. This building always interested me when we passed it on our way to Tenby. It was only when I looked at Harry's photographs that I remembered the plaque on the building that I was shown as a child. The original building may have been built in 1662 by Sir George Owen as a school or college. A new building was built on the spot in 1852 to function as the Lords of Cemaes Court House and at some time also was an inn. It was empty for ages and then we saw the sale sign. Although locally it's still known as 'College', it has been renovated and named Llys Ddu. In the magnified insets, it looks like it's harvest time, as the ladies are gathering fruit.

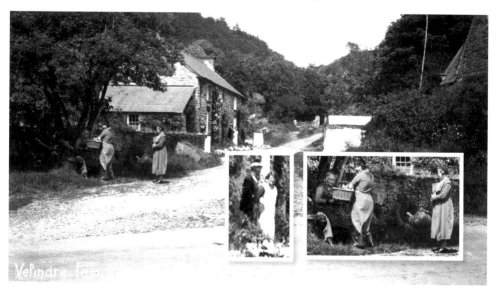

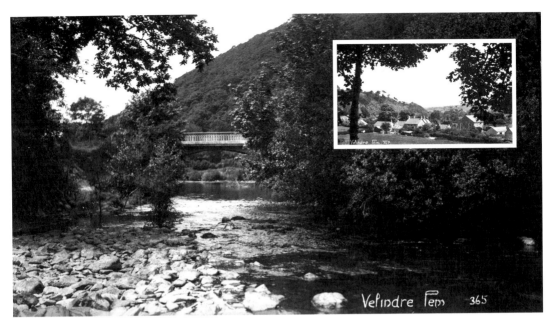

The road through Velindre towards Cardigan goes over this bridge and crosses over the River Nant Duad. This soon after joins the River Nevern, which is a spate river. In other words, it relies on rain to keep it flowing swiftly. The depth of the river can change dramatically after heavy rain but can also quickly drain away if it doesn't rain for a long time, leaving little water in the river bed. The amount of rain is important to ensure that fish have enough water to swim upstream to breed. Below, you can see the village running through the pretty valley and there seems to be a good level of water in the river.

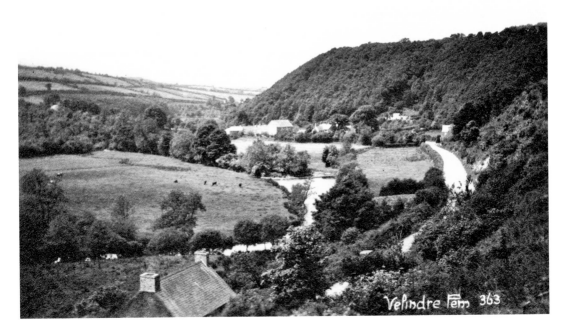

Houses of Pembrokeshire

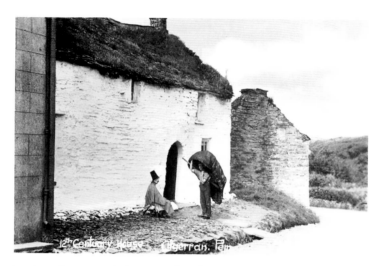

Harry had quite a few commissions to take photographs of properties, but also took some photographs of buildings he feared would be lost. I have included a selection in both of my books – some still exist and some are sadly no longer on the landscape.

The photograph above is a very old property dating back to the twelfth century. It was in Cilgerran and I remember my dad showing me the little house when I was about seven or eight years old. Some years later, we found Harry's postcard and were reminded of it. Dad checked to see if it was still there and found that it had been demolished not long after we had seen it. We both thought it was such a shame. Dad found some of Harry's notes and found that the young girl in the photograph was a Miss Gwyneth James, and the man with the coracle was a Mr Parry.

Opposite above: **Ffynone**
This is fourth of a set of up to twelve photographs that Harry was commissioned to take of Ffynone mansion in Boncath. I believe the photographs were taken in 1927, when it was sold by the Colby family to a businessman from Glamorgan.

Originally, the estate was owned by the Morgan family and sold to a Captain Colby in 1752. The mansion on the site was designed and built by John Nash, who was famous for grand buildings in London and, I believe, the gaol in Carmarthen.

The building and gardens were developed further between 1904 and 1906. Inigo Thomas was commissioned to complete this work. It certainly is a beautiful building, nestled in 20 acres of woodland. In 1987, it was bought and restored by Earl Lloyd George of Dwyfor in 1987. Currently, it is open to the public on Bank Holidays and other days, such as St David's Day and Mother's Day. They have a website that gives details (*see website references*).

Opposite below: **Lancych, Boncath, 1938**
Lancych is a very picturesque Regency/Gothic mansion that had been in the same family since the original farmhouse was built *c.* 1600. The main structure, seen in Harry's photograph, was built in the 1820s and designed by a Mr Peter Frederick Robinson. It was sold in 2003 but a fire broke out, causing devastating damage. The good news for this building was that the owners have since refurbished the main Grade II listed building, and at the time of writing it appears to be for sale.

Ffynone 4

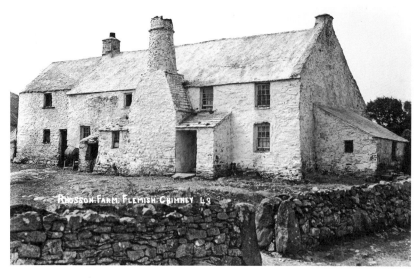

Rhosson Farm, St Davids

Rhosson Uchaf Farm is a seventeenth-century building that in Volume 30, No. 2 of the Magazine *Cornerstone* 2009, is described as, 'The most important survivor of the eight round-chimney houses recorded in 1902.' I believe Harry's photograph may be the earliest record of how the house looked in the early 1900s before more recent alterations may have been made.

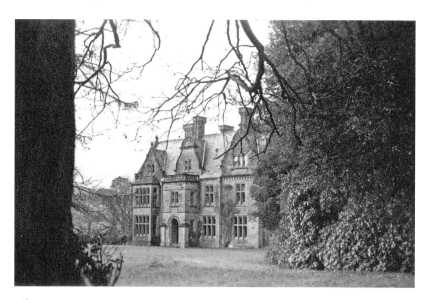

Rhos y Gilwen

Rhos y Gilwen is a Gothic-styled stone building that dates back to 1697, when there is record that a John Colby married into the family who owned it. A fire destroyed the upper storey and roof of the building in 1985 and was restored. It was then bought by the current owners in 1999 and now is a concert and arts venue, setting for weddings, conferences and courses. I visited it to attend a recital. It really is a lovely place to visit or stay at if you'd like a luxury weekend. If you're interested in live music check out the website to see what's on.

Penwaun, Nevern
This is another photograph that is part of a set taken of this interesting little Welsh home. I'm not sure why Harry took a photograph of Penwaun cottage. He may have been asked to by the owner, or noticed the possible age or unusual shape of the windows and wondered if it was once used as a chapel or church.

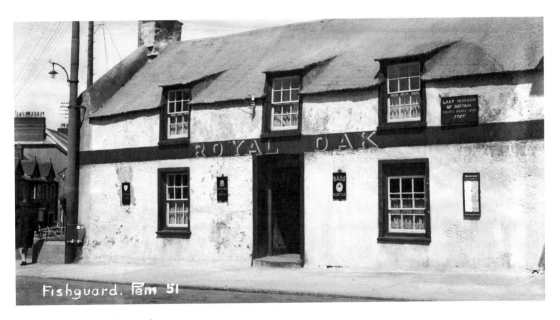

Royal Oak, Fishguard
The Royal Oak Inn retains historical importance, as it was where the French delegates came to negotiate an unconditional surrender following the unsuccessful attempted invasion of Britain in 1797.

Cromlechs, Stone Circles and Monuments

These are some of Harry's many photographs of historic landmarks in Pembrokeshire.

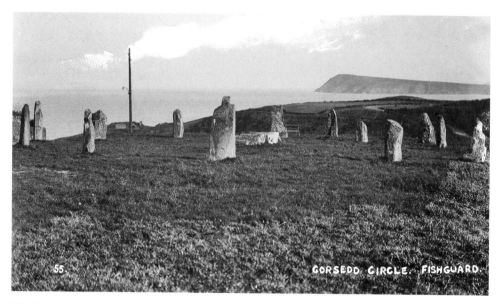

The Gorsedd Circle

It seems fitting to follow the Royal Oak Inn and begin this section with the Grosedd Circle in Fishguard. It is a 'young' circle of stones compared with many around here that was built for the 1936 National Eisteddfod of Wales. Each of the stones is inscribed with the names of the parishes that contributed them.

Pentre Ifan

These two photographs of the cromlech at Pentre Ifan give different viewpoints. The cromlech is sited high up overlooking the coast and is believed to date back to 3500 BC. In fact, if you follow the pointed end of the large capstone it lines up with the Nevern River. It seems strange to look at the remains as they are now and visualise them underground as they would have been in Neolithic times.

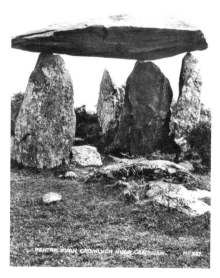

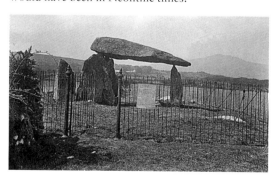

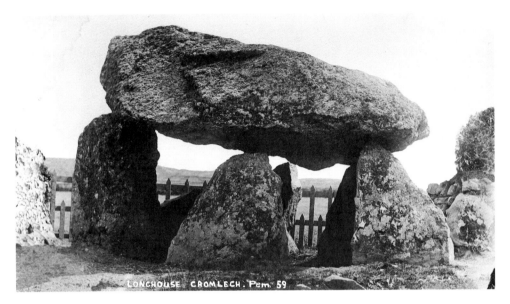

LONGHOUSE CROMLECH. Pem. 59

The Longhouse Cromlech

The Longhouse Cromlech (also called
Carreg Samson) is another monument of
the past near Abercastle. You park next
to Longhouse Farm and the cromlech is
about 100 metres away. When you see
the huge stones used on this one you'll
appreciate this second name. They are
much more robust than the ones at Pentre
Ifan. Of the seven uprights that may have
been intended to hold up the enormous
oval capstone, only three actually perform
that function. Two types of stone are used,
but I don't believe anyone knows whether
there is some reason for this choice.

The Mesur-y-dorth stone ('measure
of the loaf') is part of the wall on the
roadside between Heulfre and Maer
y Garreg Farm, near Croesgoch on
the A487. It's a very early Christian
stone and is believed to date back to
sometime between the seventh and ninth
centuries. There is a story that, at some
point, possibly in St David's time, when
there was great poverty, he may have
determined that the size of a loaf should
be reduced to fit within the circle on the
stone. On the other hand, there is also an
explanation that the stone indicated this
was the last place pilgrims could stop for
a meal before travelling the last 6 miles to
St David's Cathedral for their next meal.

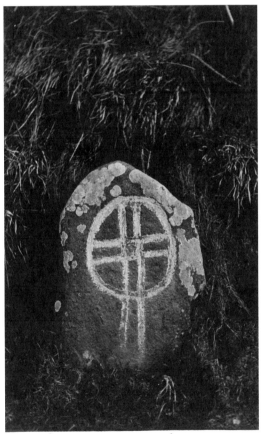

*Mesury dorth
Croesgoch*

Cross at Pencaer

The cross at Pencaer is another ancient inscribed stone that as yet I haven't been able to find any information about, apart from the fact that Harry found it in or near Pencaer, Pembrokeshire. I do remember hearing that back in the 1300s there was a church in Pencaer overlooking the sea. The photograph gives no information other than it appears to be built into a wall. From AD 400 to 1000, it seems that there were many Celtic inscribed stones made. Some dating to the tenth or eleventh century were found built into Llanwnda parish church wall around 1881, when the church was rebuilt. I wonder if this was one of those stones.

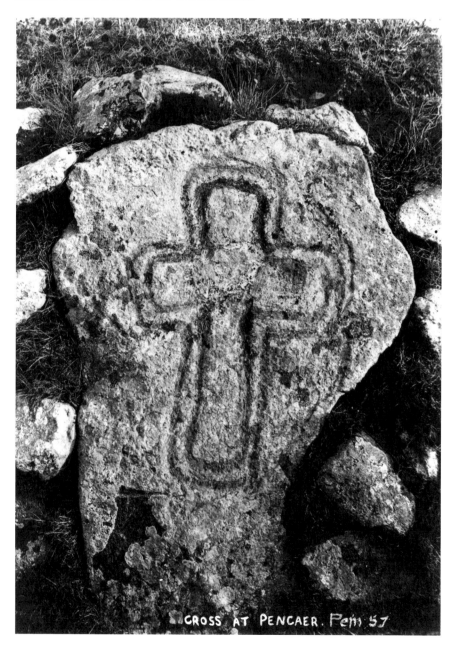

CROSS AT PENCAER. Pem 57

Acknowledgements

I would like to thank: Cyril Burton for sharing his historical memories with me and lending me his collection of books, glass plates and photographs; Peter Davis, author and dedicated postcard collector, for generously sharing his time, support and vast knowledge of the past photographic world of postcards related to my family; Peter Fudge, my husband, who patiently proofread my book; Glen Johnson, historian and author, for sharing his knowledge of our local history, how it related to my grandfather's work and also for suggesting and encouraging me to produce this book; Rob Squibbs, my cousin, for becoming part of this book by lending me our grandfather's plates and negatives.

References

Admiralty Hydrographic Department, *Sailing Directions for the West Coast of England* (1870).

Baring-Gould, S., *A Book of South Wales* (1905).

Davies, D., 'Those were the Days', *Tivy Side Advertiser* (1984).

Davies D. T., *Mainly Cenarth* (2010).

Evans, J. T., *The Church Plate of Cardiganshire* (1914).

Maddox R. L., *An Experiment with Gelatino-Bromide* (1871).

Figgis's N. P., *Prehistoric Preseli* (2001).

Green. E. T., and D. Davies, Cardiganshire Antiquarian Society, *Transactions and Archaeological Record* Vol. 2, No. 1 (1915).

Johnson G. K., *St Dogmaels Uncovered: Heritage of a Parish* (2007).

Lewis, S., *A Topographical Dictionary of Wales* (1833).

Lynn-Thomas, J., *Key of All Wales* (1932).

Language and Heritage Committee, *Cymuned Cilgerran mewn Lluniau/Cilgerran Community in Picturesw* (2007).

Website References

British Listed Buildings (http://www.britishlistedbuildings.co.uk/)
Carew Castle (www.carewcastle.com)
Castle Martin Information (http://www.milfordmarina.com/castlemartin-range-1/)
Ffynone (http://www.ffynone.org)
Friends of Friendless Churches
 (http://www.friendsoffriendlesschurches.org.uk/CMSMS/index.php)
Lancashire Telegraph (http://www.lancashiretelegraph.co.uk)
Manorbier History (http://www.manorbier.org.uk/index.php/history.html)
Not So Official Newport Pembs Site (http://www.newportpembs.co.uk)
Pembrokeshire Coast National Trail (http://nt.pcnpa.org.uk/)
Save Me (http://save-me.org.uk/FOX_Clifford_pellow.html)
Tenby Guide (http://www.tenbyguide.com/caldey.asp)
Visit Pembrokeshire (http://www.visitpembrokeshire.com)
Welsh Biography Online (http://www.wbo.llgc.org.uk)

Image Credits

Abraham Squibbs: Figs. 7, 9 and back cover portrait.
Arthur Squibbs: Author: Figs. 2, 3, 4, 20, 21, 26, 29, 34, 35.
Harry and Arthur Squibbs: Fig. 8.
Dolly Squibbs: Fig. 33.
Vivian Squibbs: Fig. 1.